SHORELINE PROJECT

ELIZABETH TURK

LAGUNA ART **MUSEUM**

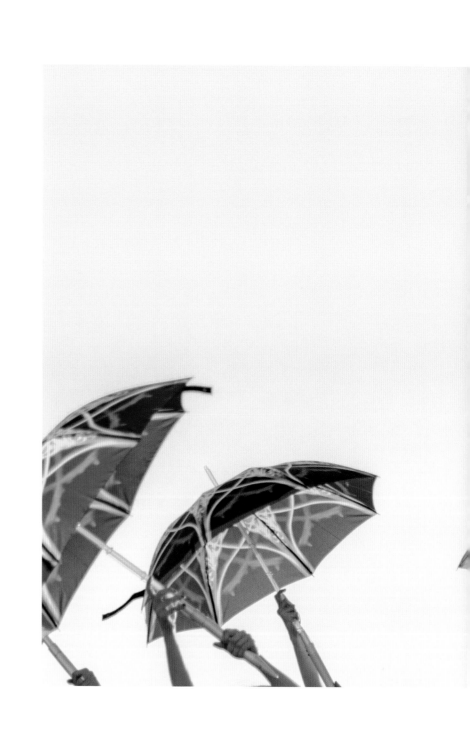

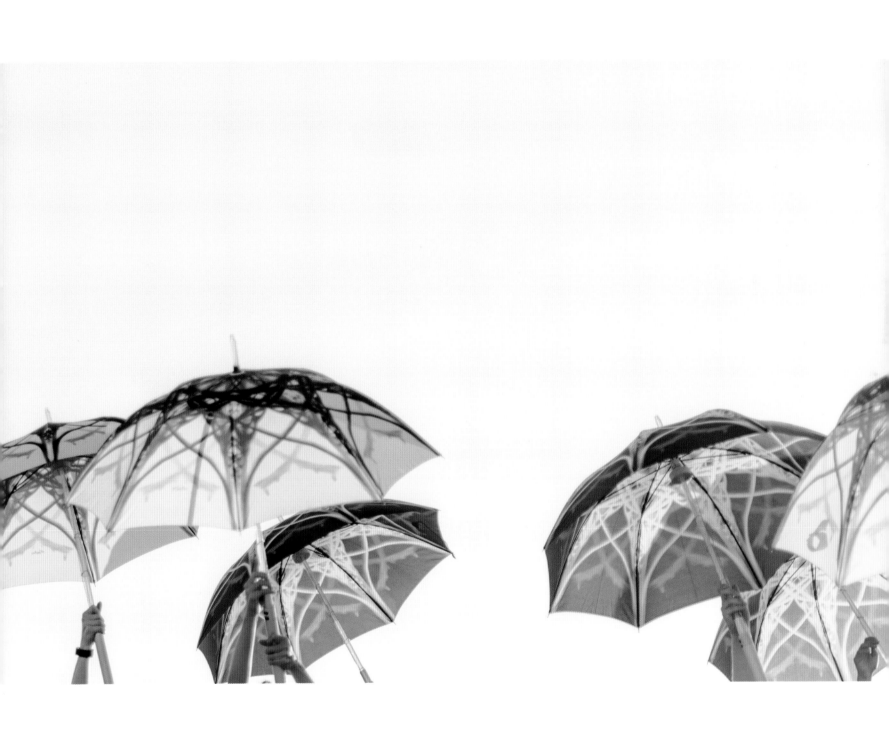

CONTENTS

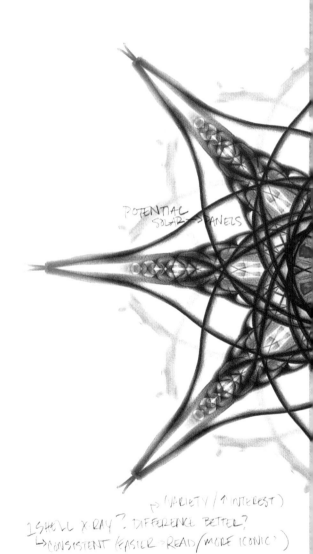

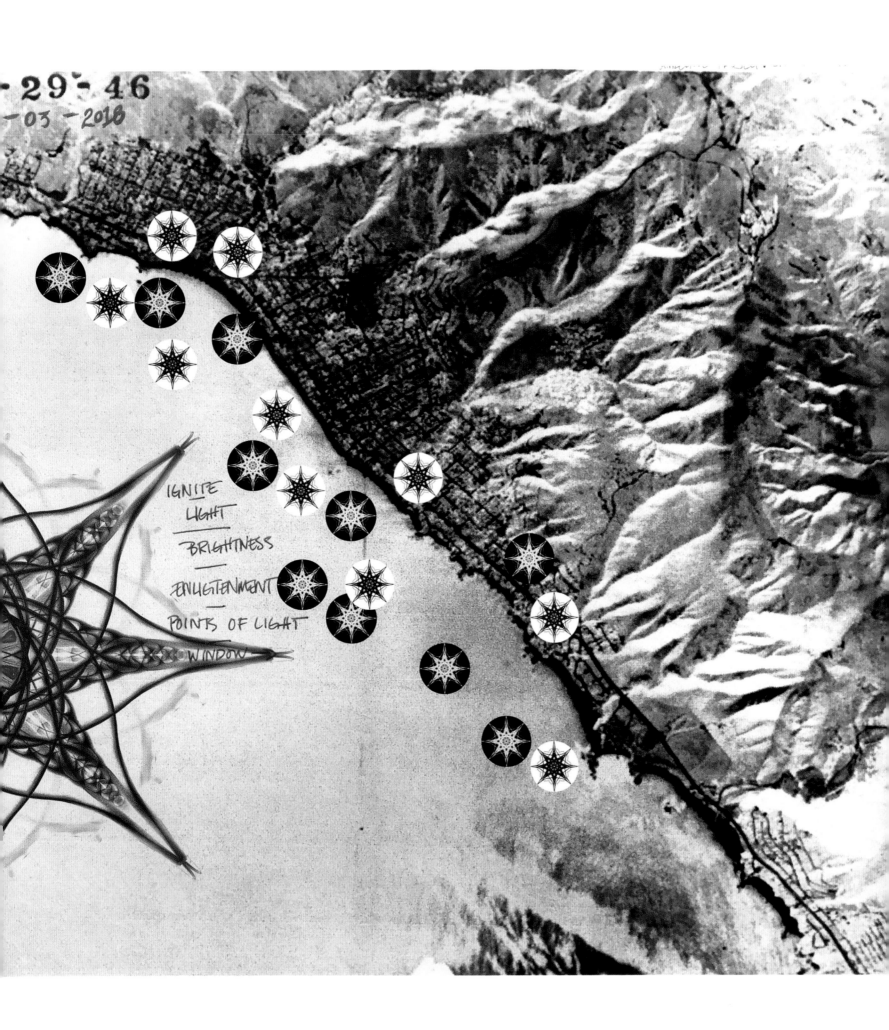

FOREWORD
MALCOLM WARNER

Umbrellas don't immediately suggest happiness and creativity, especially for a native of rainy England. But there was no resisting the sheer twirlability of the version Elizabeth Turk created for her Shoreline Project.

Elizabeth tells me that it all began with the little umbrellas in drinks we had at the Royal Hawaiian restaurant in Laguna Beach while discussing the possibility of a commissioned piece for the museum. I think she may be kidding about that. In any case, once she had the concept, happenstance played little part in the way she carried it through, which was both inspired and meticulous. We knew that all would be right on the night of Shoreline Project, and it was successful beyond our most optimistic imagining.

She had worked with us on a wonderful exhibition inside the museum in 2014-15, *Elizabeth Turk: Sentient Forms*. It included some of the X-ray mandala light boxes that would morph into the illuminated umbrellas. But Shoreline Project—hugely ambitious, free to all, and out in the open—was something else. On behalf of the museum, I offer the warmest congratulations to Elizabeth, Laura Siapin, and the rest of Team Turk, as well as the thousand Shoreline Project participants, on the joyful experience they created together.

It was part of the museum's Art & Nature festival, held annually since 2013. Keen to bring art out from behind our walls and into nature, we have commissioned a number of temporary pieces on Main Beach as centerpieces for the festival, whether sculptural installations or performances. The previous artists were Jim Denevan (2013), Lita Albuquerque (2014), Laddie John Dill (2015), Phillip K. Smith III (2016), and Pablo Vargas Lugo (2017). It was fascinating to see how Elizabeth picked up on ideas that have emerged repeatedly in the Art & Nature commissions: the reference to a feature of everyday beach life, in her case the beach umbrella; the conception of the work as community-forming; and, above all, that naturally occurring preoccupation of the California artist—playing with light.

In addition to the commissioned work of art, Art & Nature programs also include exhibitions, films, talks, panels, and a keynote lecture. To complement Elizabeth's work, we could hardly have had a more pertinent keynote than Jane Munro's on Charles Darwin—his ideas

about art and nature, natural selection and beauty. It brought out a level of meaning in the Shoreline Project that might otherwise have remained latent.

My colleague and partner in shaping Art & Nature from the outset has been the museum's curator of education, Marinta Skupin. On our museum side of the Shoreline Project, Marinta and I are deeply thankful for the support we had from Kristen Anthony, Caitlin Reller, and Elizabeth Rooklidge.

All who have fond memories of that year's Art & Nature and Shoreline Project owe a debt of gratitude to our sponsors: Yasuko and John Bush; Jane and Joe Hanauer; Chris Quilter; the McBeth Foundation; the Festival of Arts Foundation; the Ebell Club of Laguna Beach; Trammell Crow Company, with special thanks to Tom Bak; Pacific Life Foundation; the William Gillespie Foundation; and others who have preferred to remain anonymous.

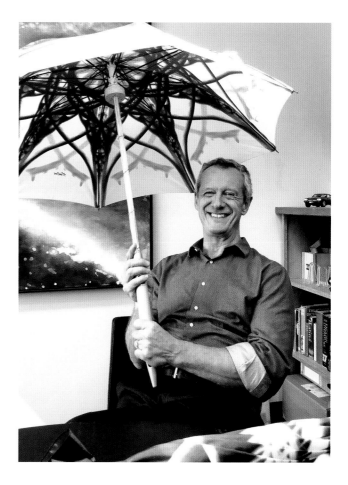

This is the second Art & Nature-related book that we have published with California State University, Fullerton, the first highlighting installations in Laguna and elsewhere by Phillip K. Smith III. Our thanks to Meg Linton and Mike McGee for their insightful essays on the Shoreline Project—and in Mike's case for masterminding the fruitful Cal State Fullerton-Laguna Art Museum partnership over the past several years. Thanks also to the other friends at Cal State Fullerton who worked so effectively to move the publication along, Karen Hendon and Jackie Bunge, to editor Sue Henger, and to designer Jim Scott.

Malcolm Warner, PhD
Executive Director
Laguna Art Museum

SEASHELL X-RAY MANDALAS

CONSTRUCTING MEANING THROUGH RESEARCH, DEVELOPMENT, AND TESTS

CONSTRUCTING LAYERS OF MEANING ⇒ NATURAL FOUNDATIONS/FORMS INTERPRETATIONS OVER TIME/DEPTH IN MEMORY → EXPANDING MOMENTS → HOW TO CREATE EXPONENTIAL ASSOCIATIVE THOUGHTS?

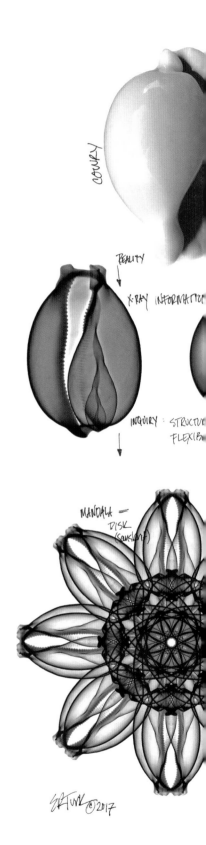

CONCH

REALITY →

X-RAY INFORMATION

INQUIRY: STRUCTURE FLEXIB...

MANDALA = DISK (SANSKRIT)

ER TURK © 2017

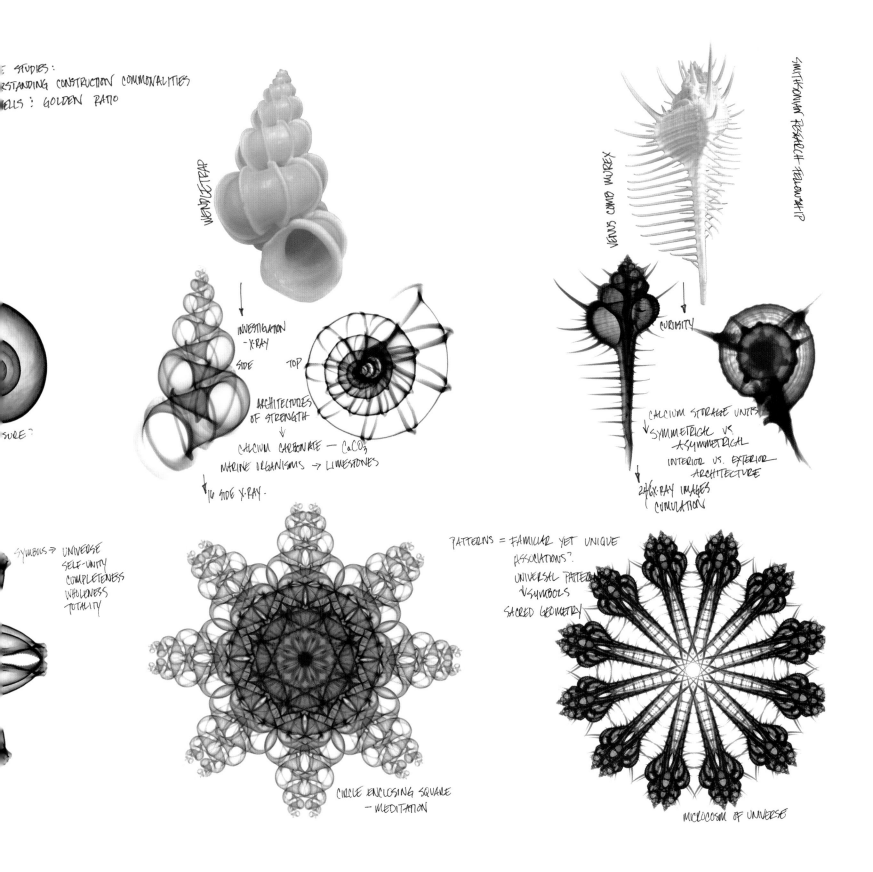

STUDIES:

...RSTANDING CONSTRUCTION COMMONALITIES

...ELLS : GOLDEN RATIO

WENDLETRAP

SMITHSONIAN RESEARCH FELLOWSHIP

VENUS COMB MUREX

INVESTIGATION
-X-RAY

SIDE TOP

ARCHITECTURES
OF STRENGTH
↓
CALCIUM CARBONATE — CaCO₃
MARINE ORGANISMS → LIMESTONES

↓ 16 SIDE X-RAY.

CURIOSITY

CALCIUM STORAGE UNITS
↓ SYMMETRICAL VS.
 ASYMMETRICAL
INTERIOR VS. EXTERIOR
 ARCHITECTURE
↓
246 X-RAY IMAGES
CUMULATION

...SURE?

SYMBOLS ⇒ UNIVERSE
SELF-UNITY
COMPLETENESS
WHOLENESS
TOTALITY

CIRCLE ENCLOSING SQUARE
— MEDITATION

PATTERNS = FAMILIAR YET UNIQUE
ASSOCIATIONS?
UNIVERSAL PATTERNS
↓ SYMBOLS
SACRED GEOMETRY

MICROCOSM OF UNIVERSE

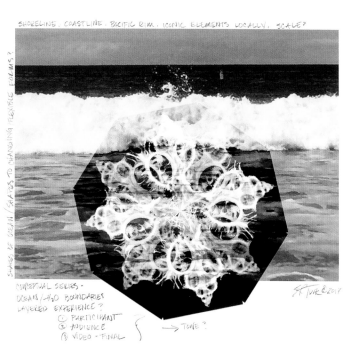

SHORELINE. COASTLINE. PACIFIC RIM. ICONIC ELEMENTS LOCALLY. SCALE?

CONCEPTUAL SERIES -
OCEAN/H$_2$O BOUNDARIES
LAYERED EXPERIENCE?
① PARTICIPANT
② AUDIENCE
③ VIDEO - FINAL

⟶ TONE?

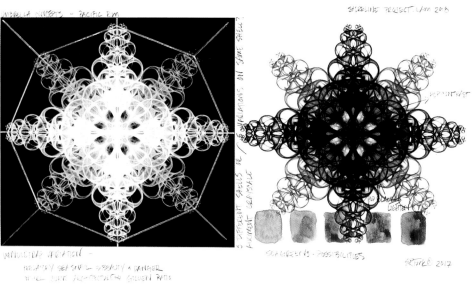

MANDALA MOMENTS - PACIFIC RIM

SHORELINE PROJECT LAM 2018

FLIP NOT TWIST

5 DIFFERENT SHELLS OR / 5 ITERATIONS ON SAME SHELL?

SEA GREENS - POSSIBILITIES

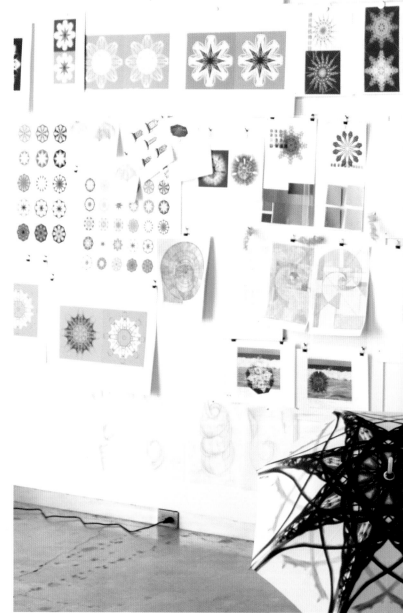

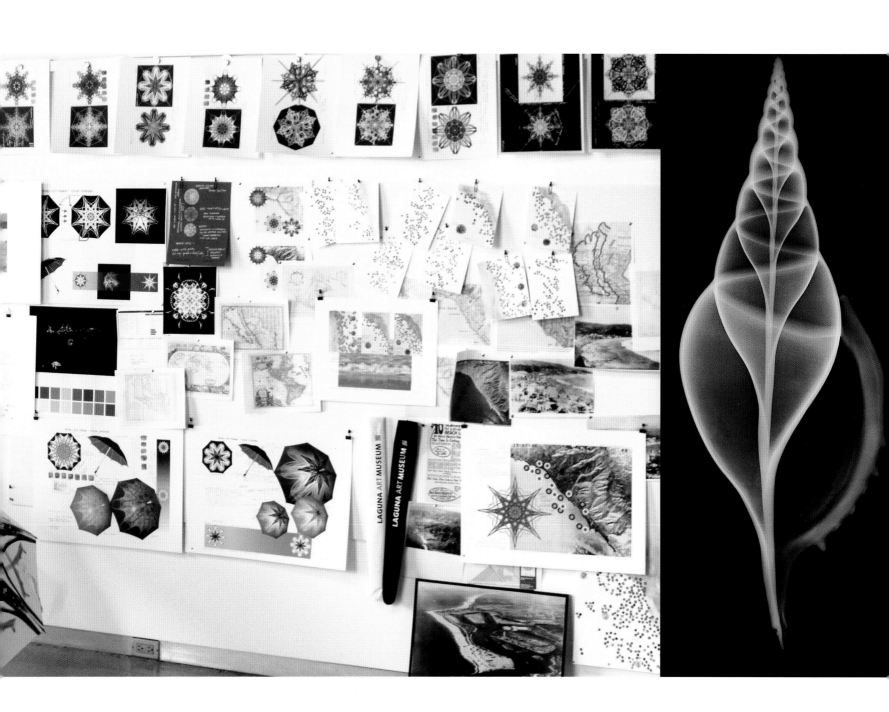

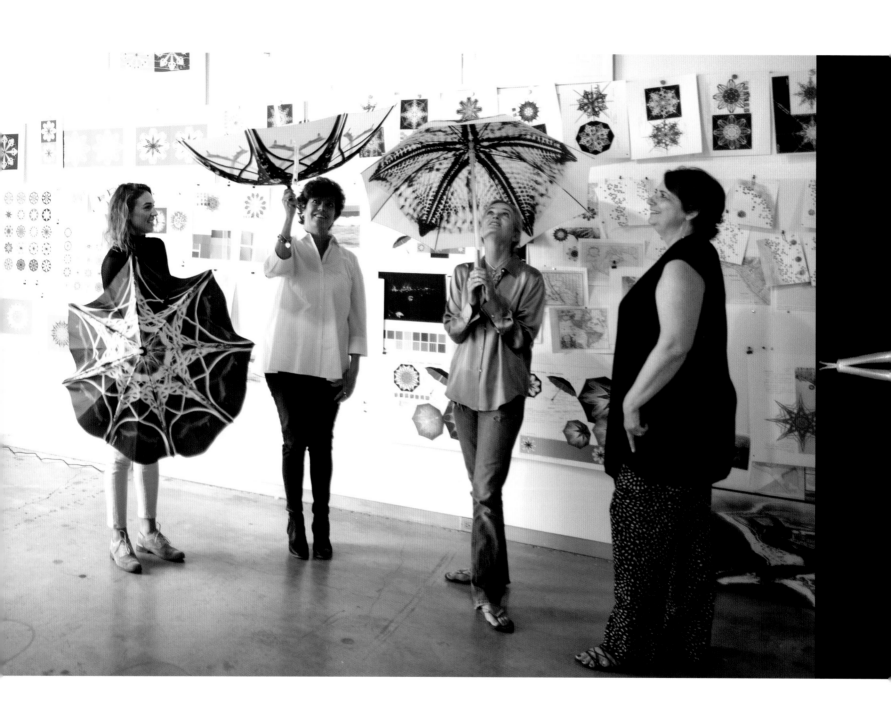

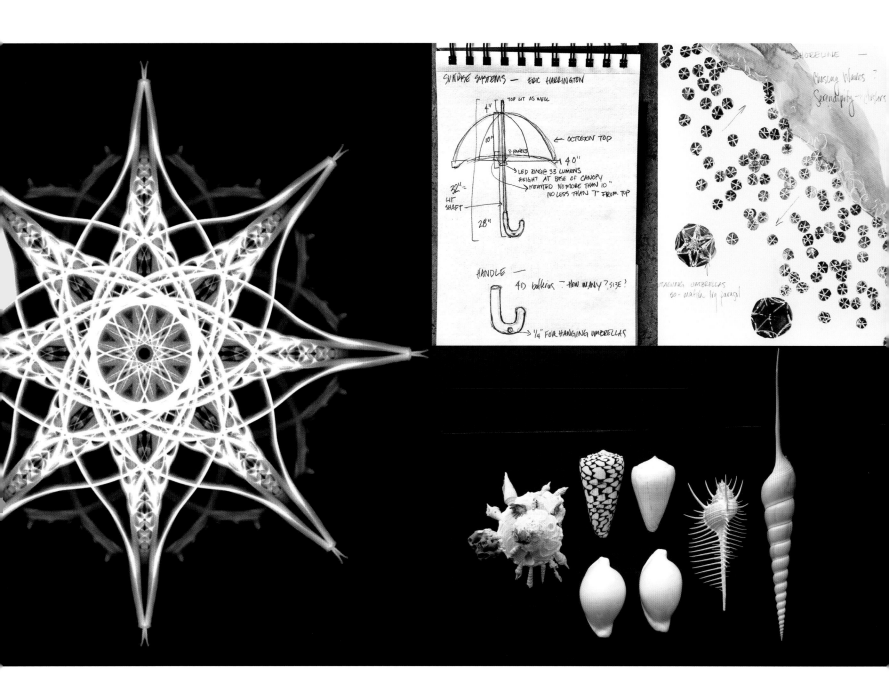

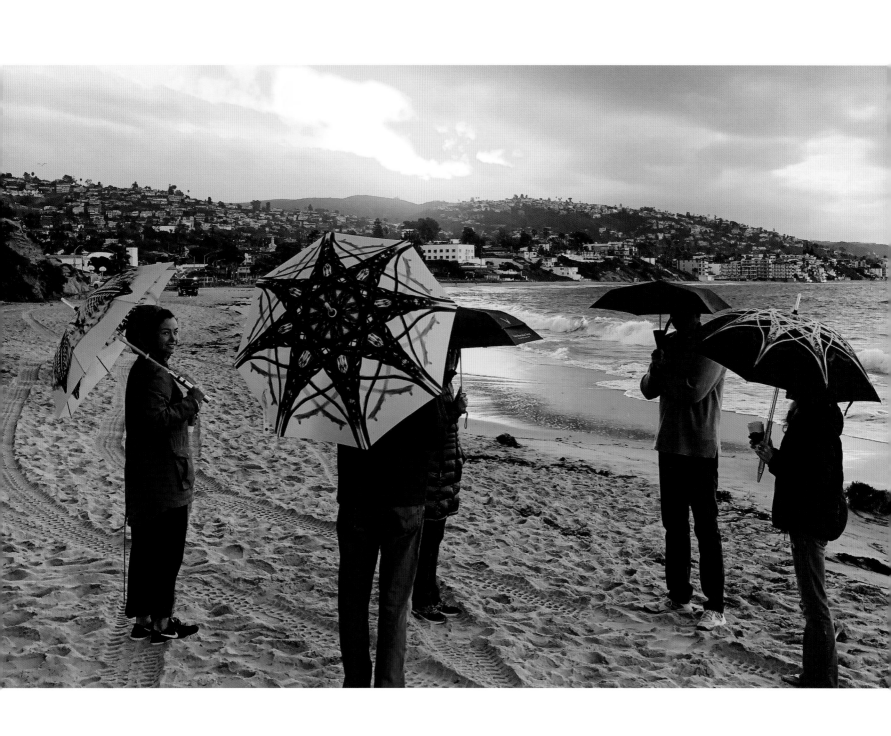

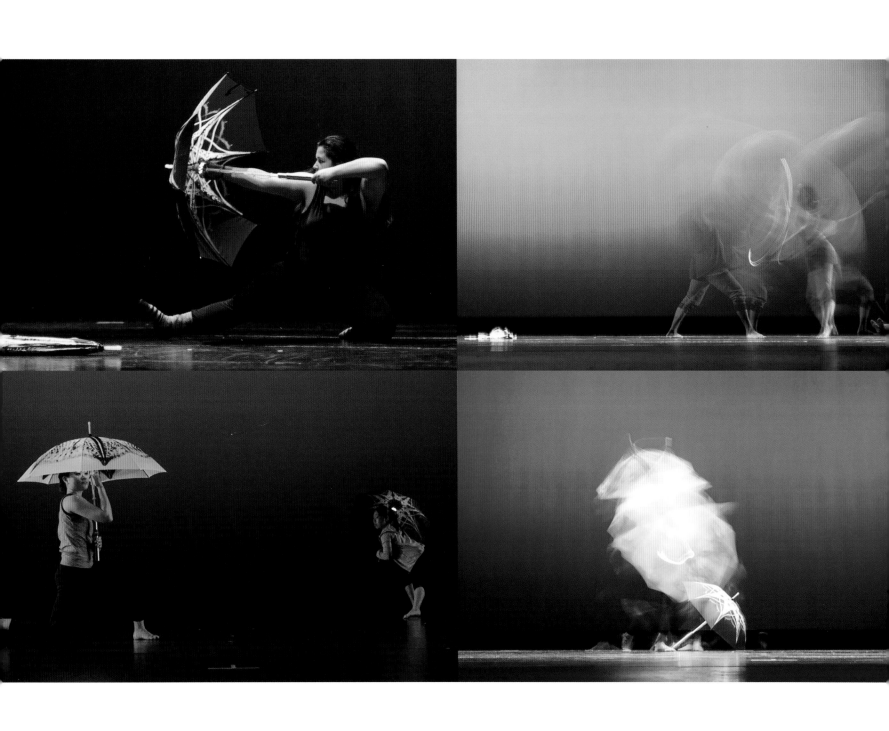

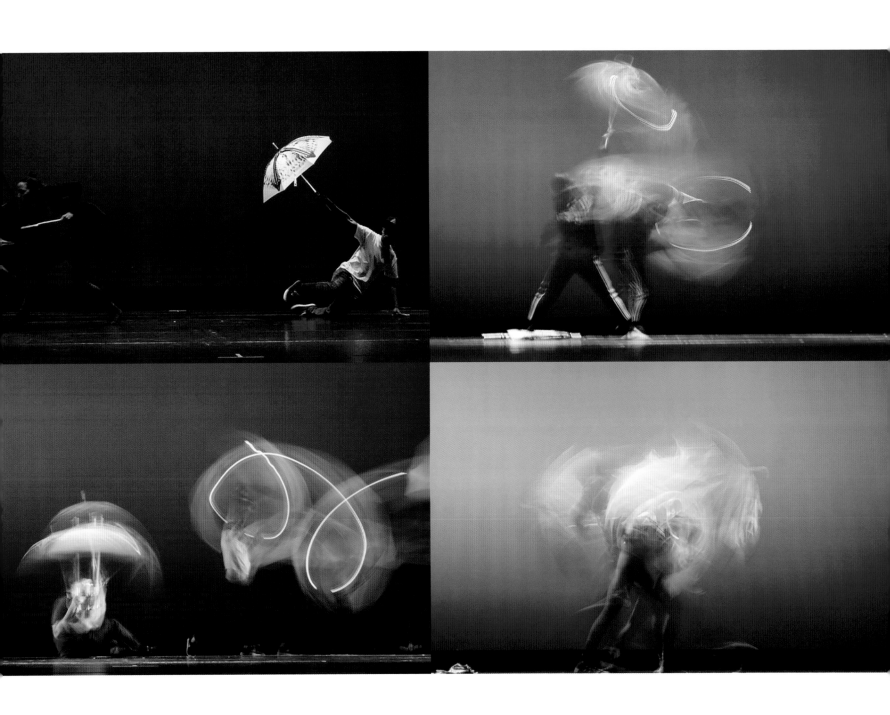

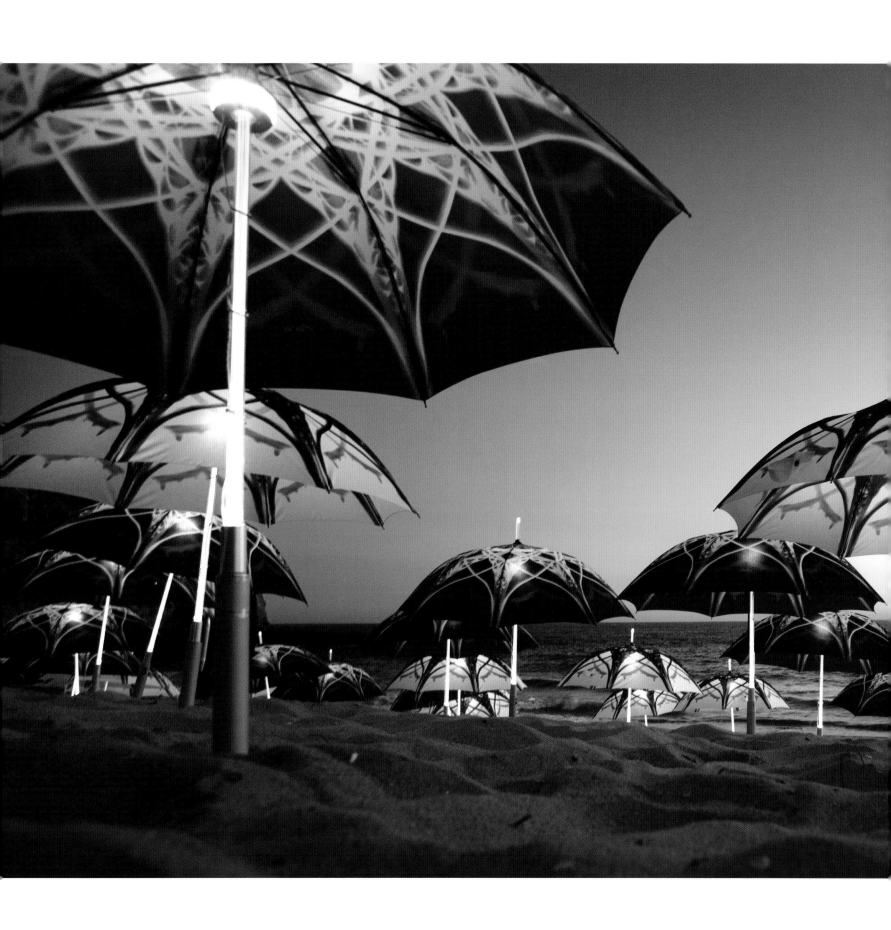

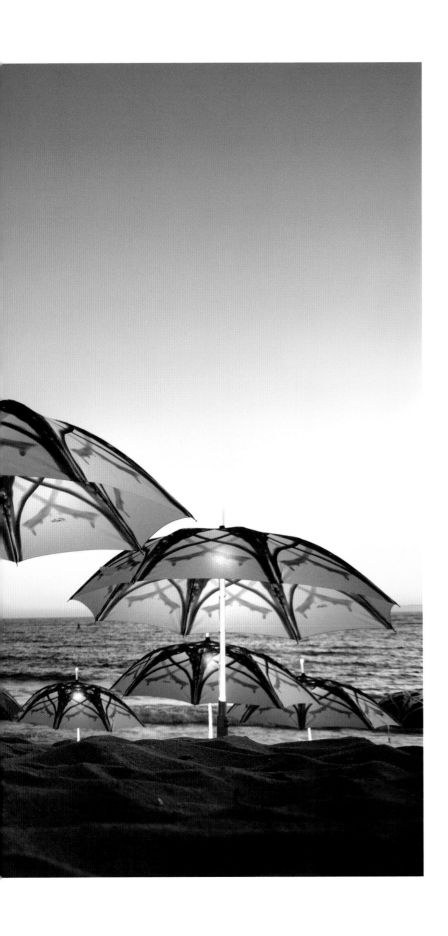

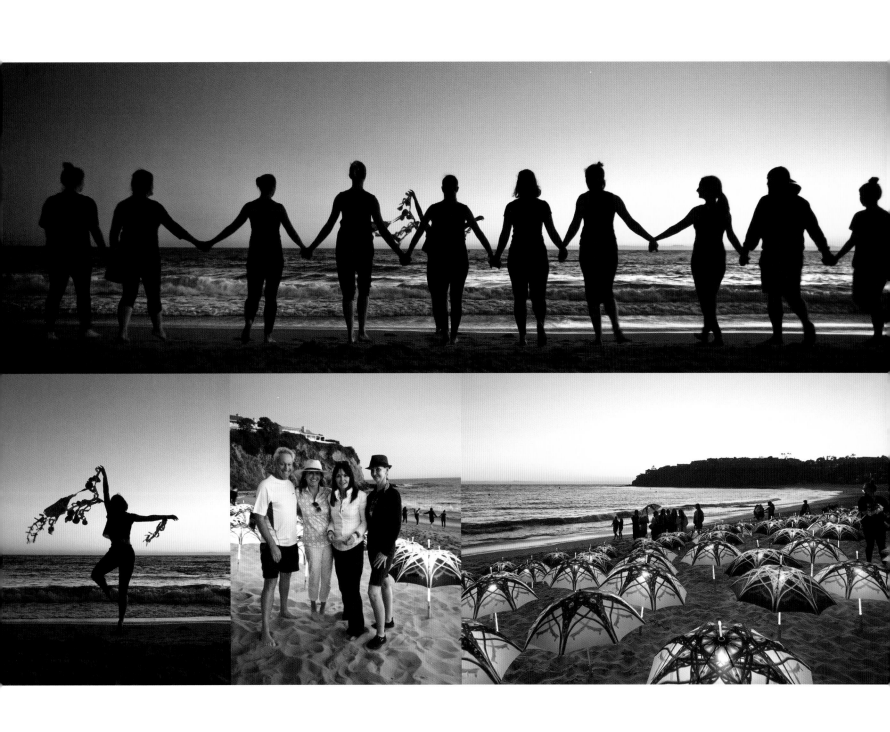

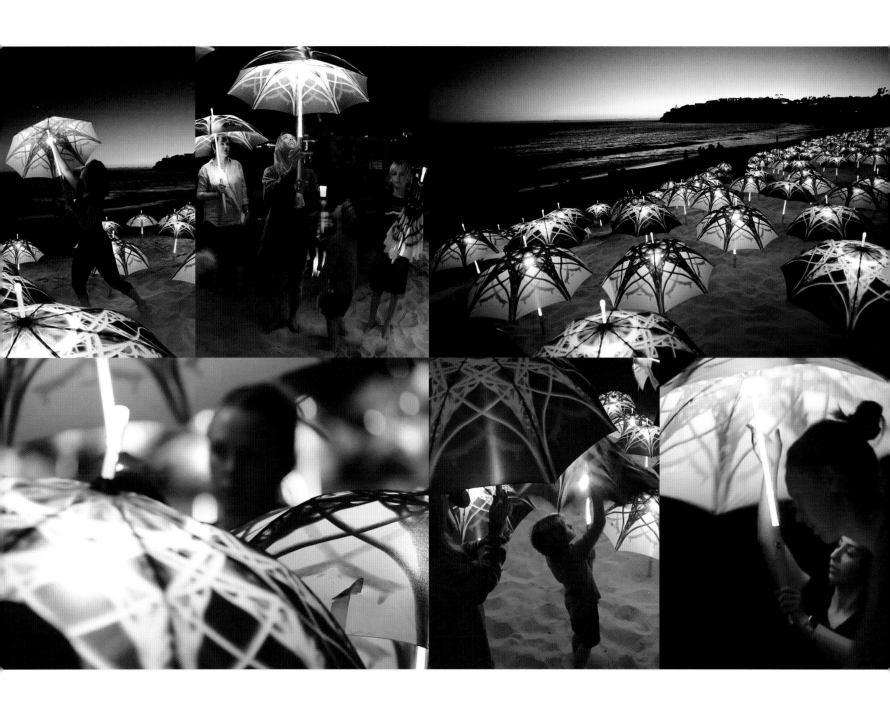

MOVEMENT

INSPIRING MOVEMENT WITH DANCE

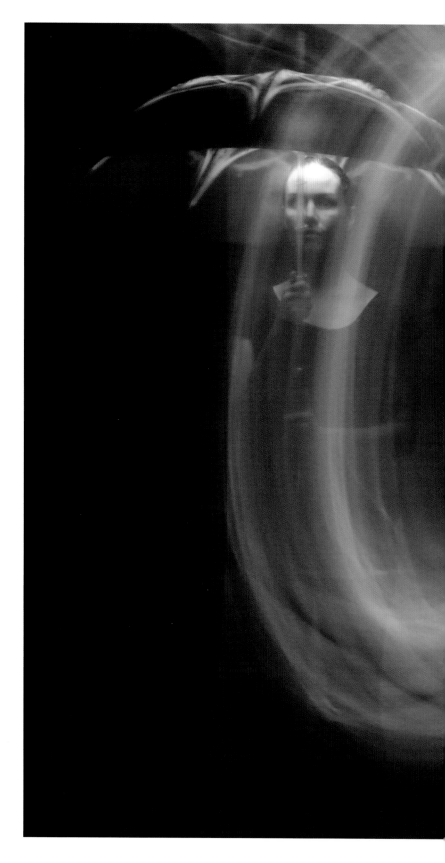

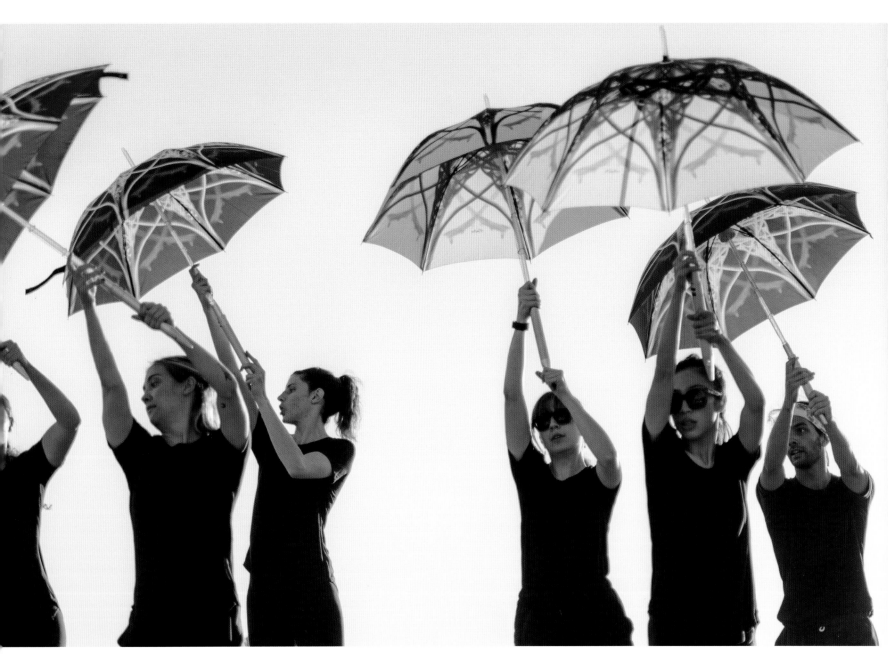

LARA WILSON

THE ASSEMBLY DANCE COMPANY

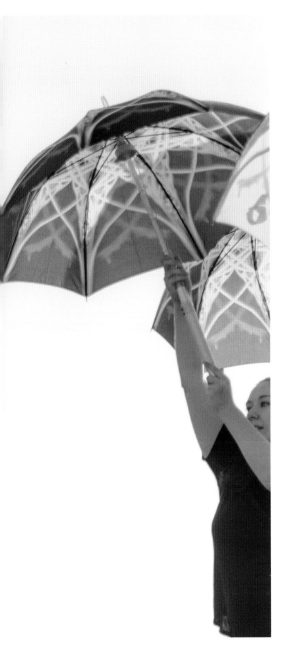

We planned for chaos. I think all of us had fears about how things could go wrong. But people were kind, smiling, respectful. And when the sun went down and the drums came up, the mood was like a carnival from some parallel universe or culture—or from an artist's imagination—where a simple umbrella and a beach can be the framework for such pulsating, creative aliveness.

As a dancer and choreographer, I was interested from the beginning in how people's bodies would respond. I expected them to open their umbrellas cautiously, to look around and ask, "what now?," or to be afraid to look stupid, as I have on countless occasions. That the thousand umbrellas opened instantaneously and enthusiastically at the first beats of the drum was an incredible way to be proven wrong. The work was its own living thing. The umbrellas and the darkening sky quickly became cover for slow dances, for kisses, for choreographic impulses that might've otherwise gone ignored—or not have occurred at all. The evening gave permission and imperative for people to move their umbrellas, and by extension their bodies, in simple ways, in unusual ways, and perhaps in ways they had never moved before. By contributing to a whole of 1,000 individuals, each unequivocally belonged, and from that place of belonging, spent some hours laughing, dancing, and creating their own light.

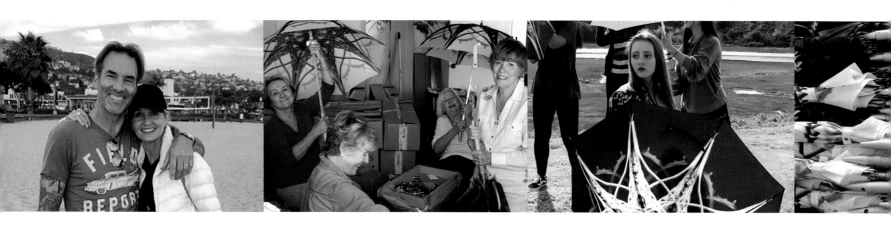

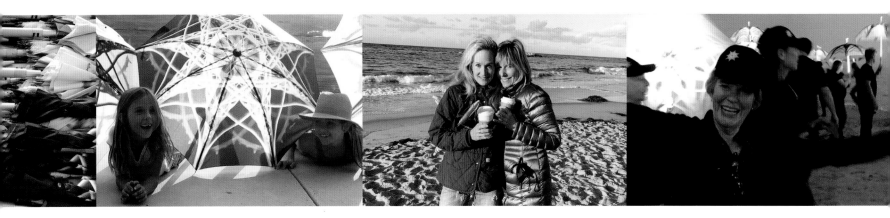

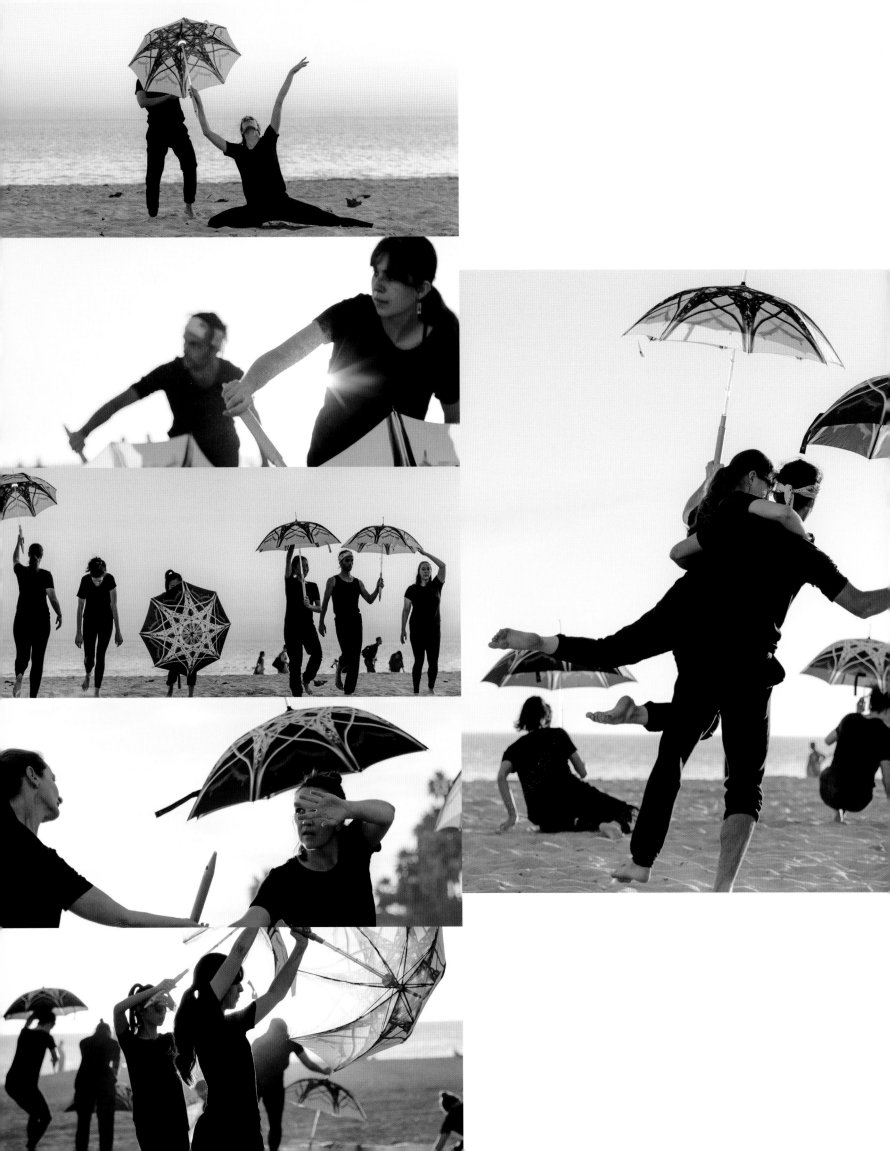

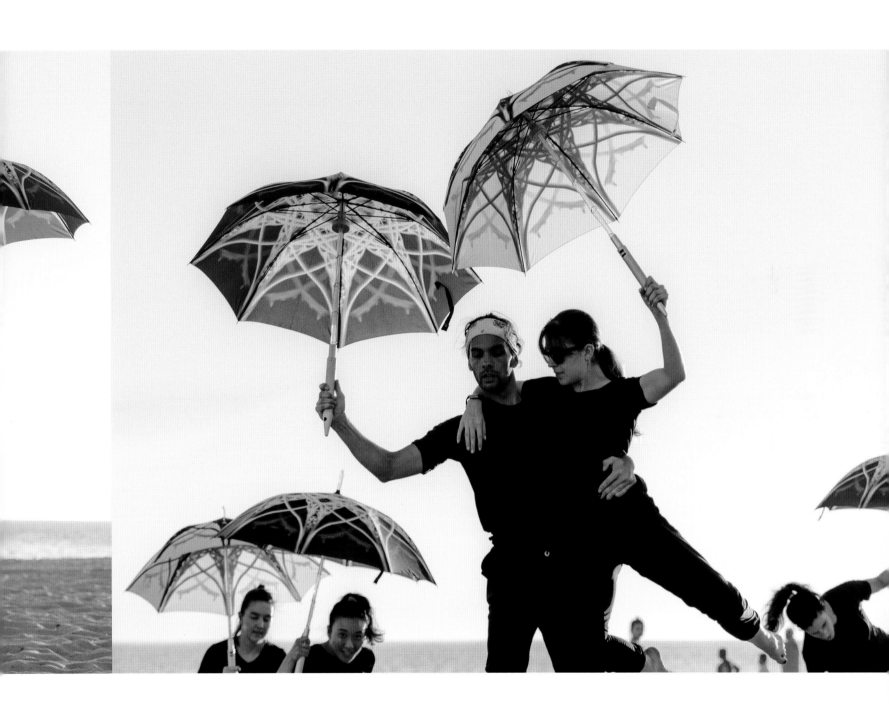

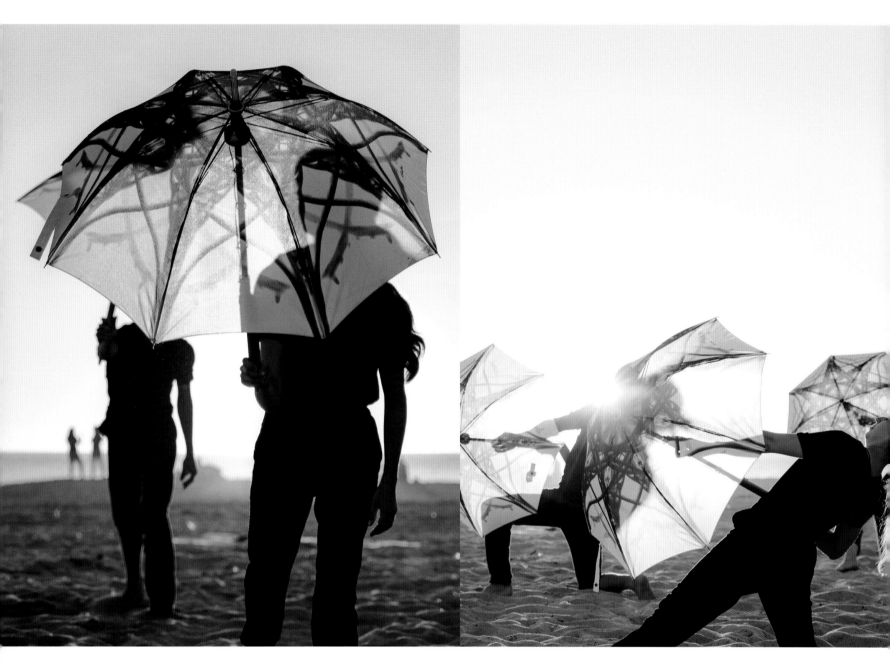

SOUND
BACH CELLO SUITE NO.1 IN G MAJOR

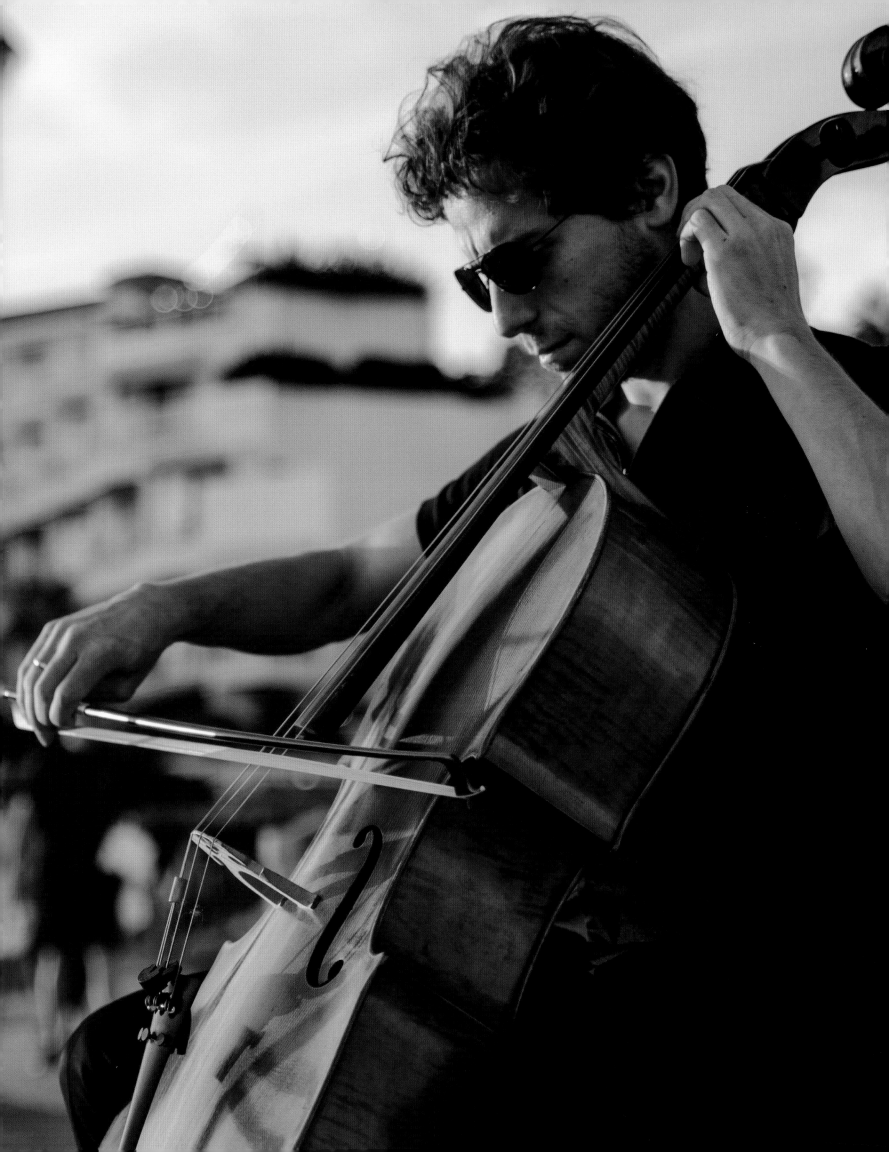

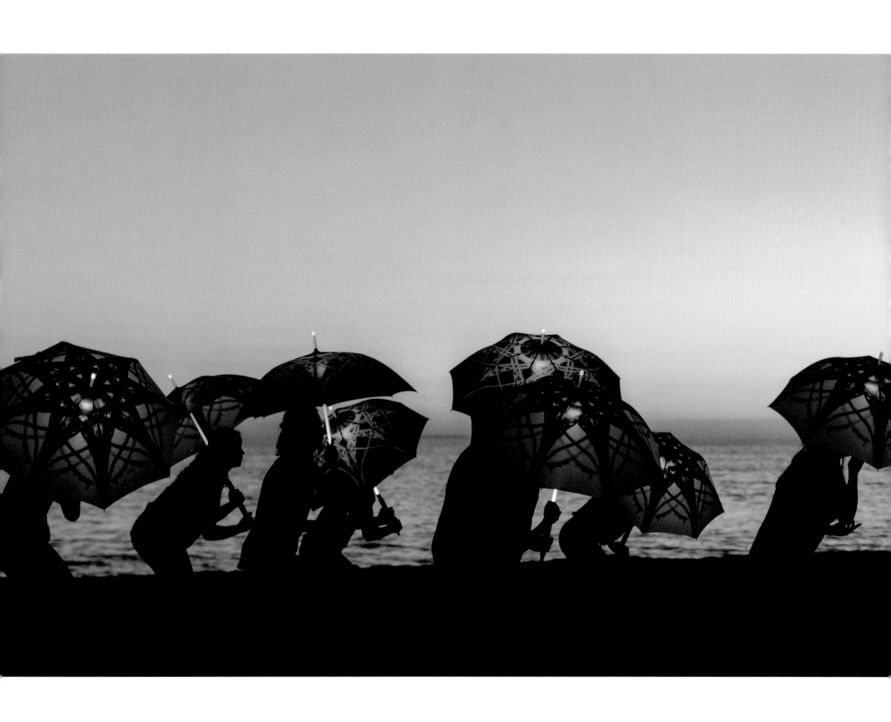

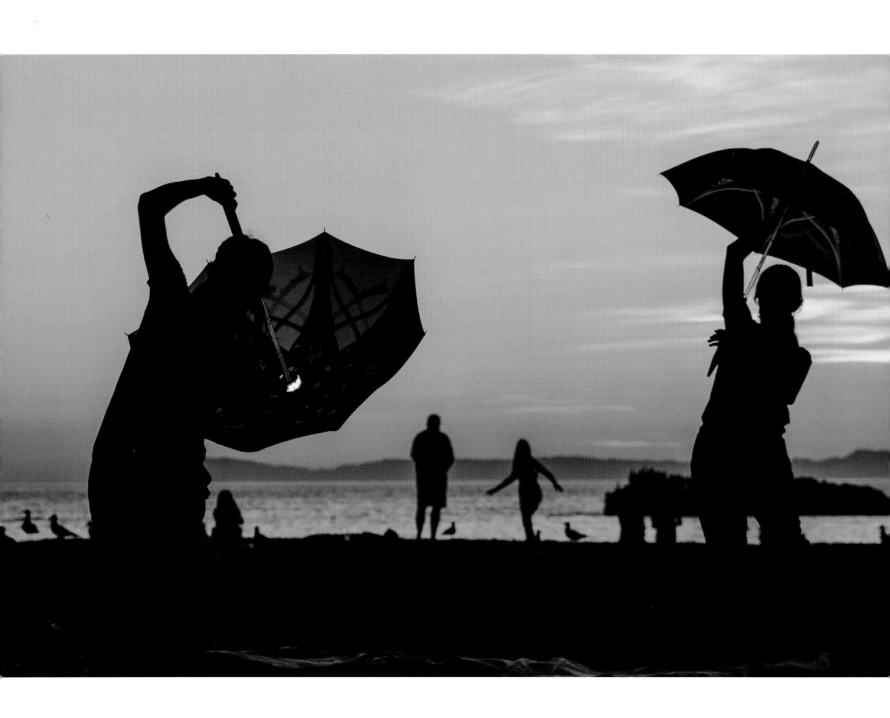

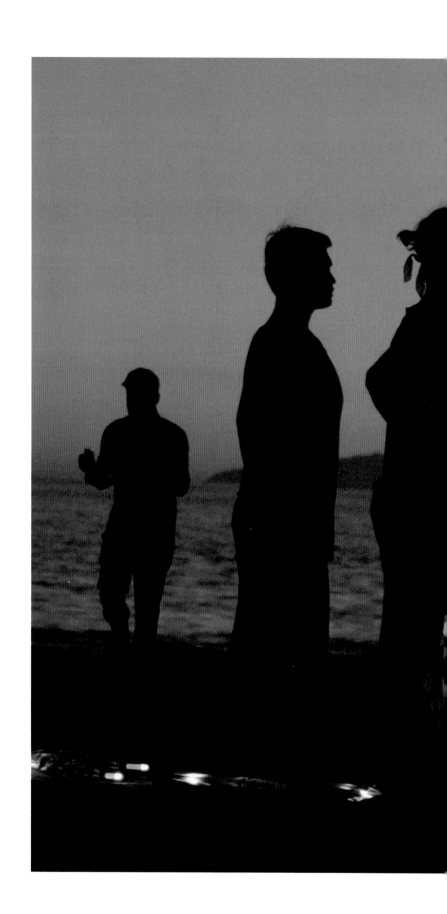

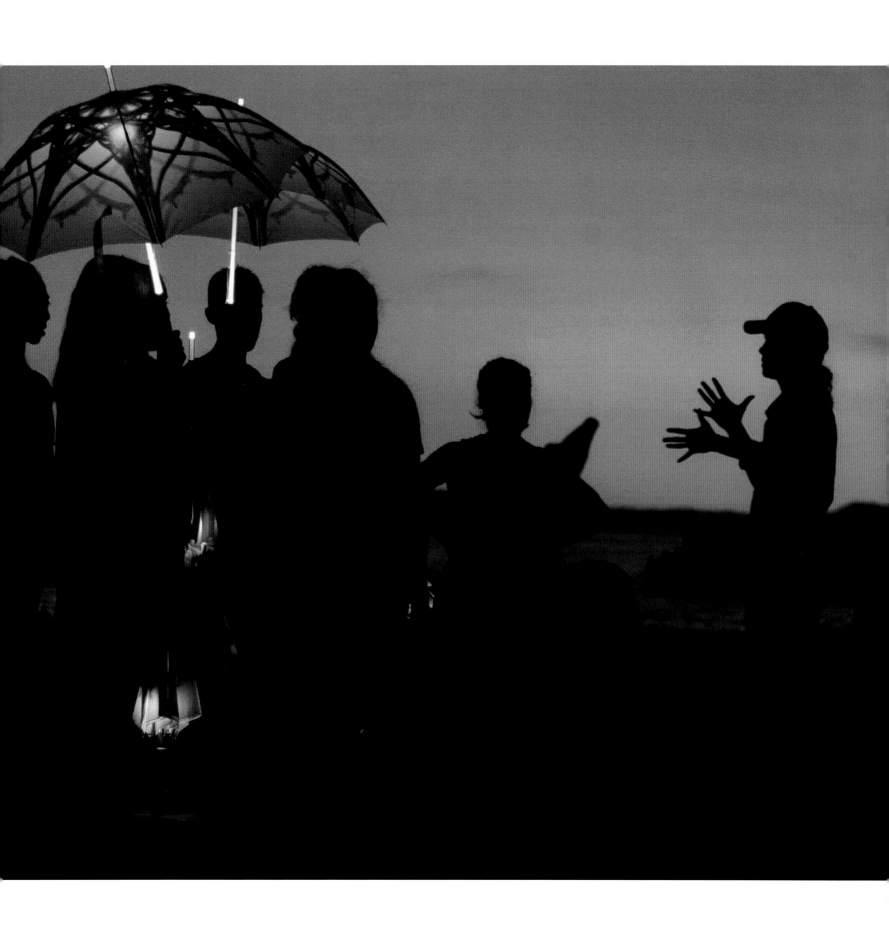

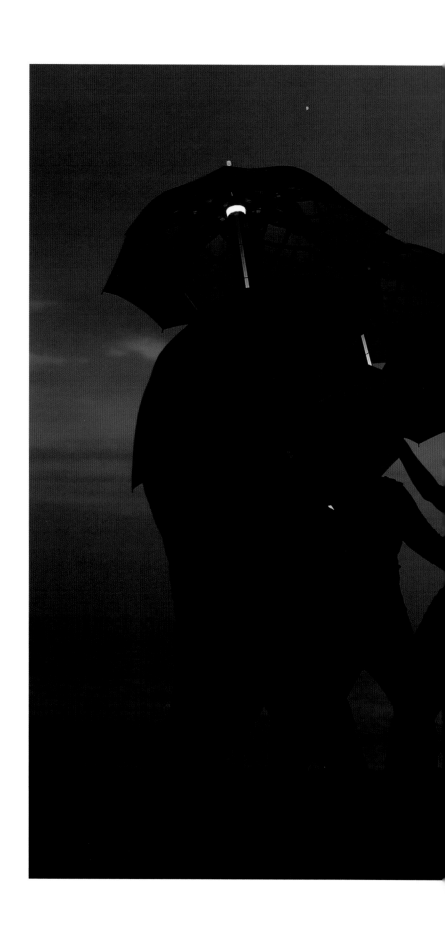

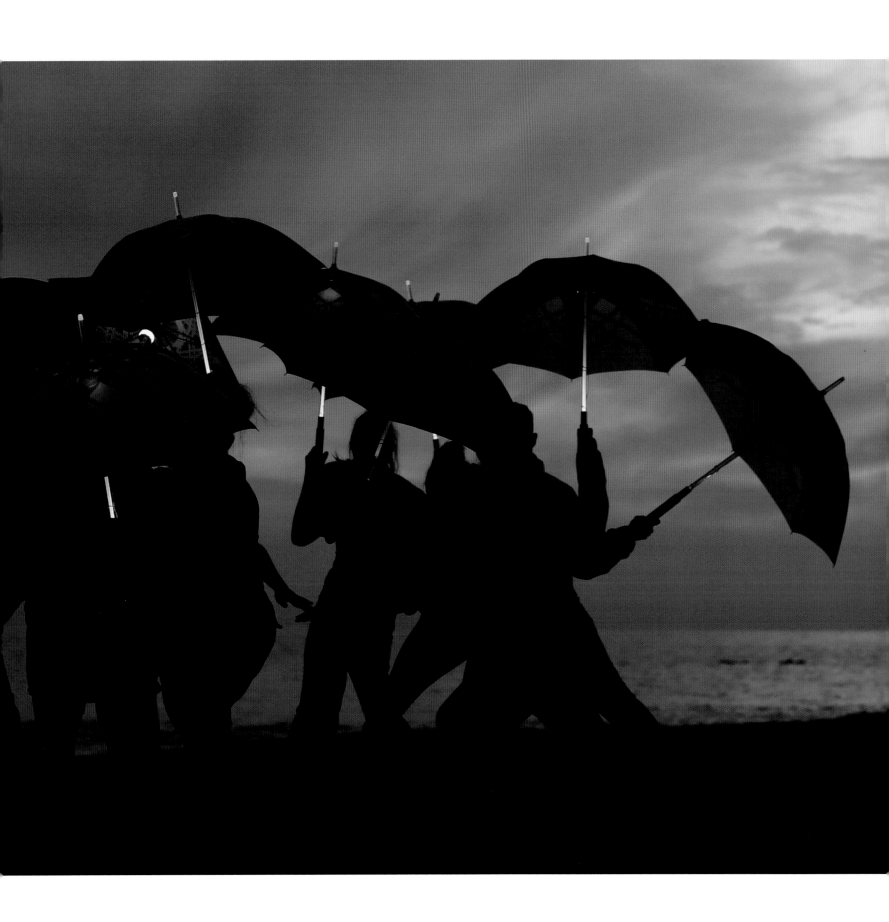

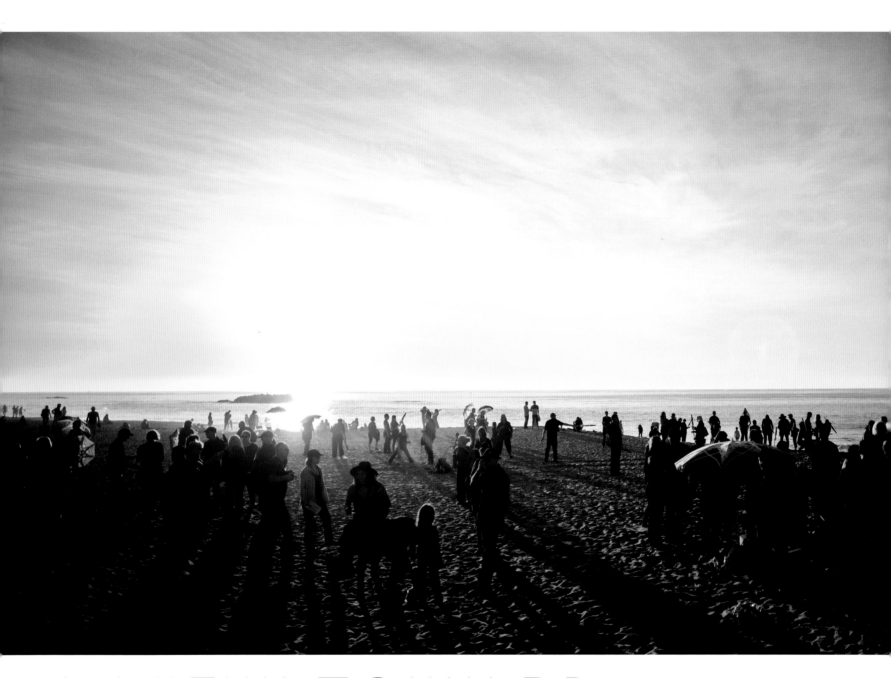

A VIEW TOWARD
SHORELINE

MIKE MCGEE

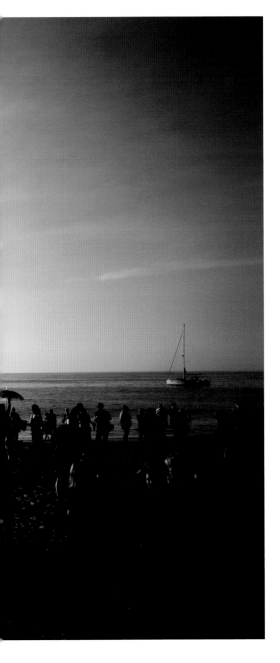

Imagine one night at dusk you are walking alongside Pacific Coast Highway, or perhaps on the boardwalk, in downtown Laguna Beach. As you approach the beach you see people inexplicably moving around holding umbrellas lighted with images of what seem to be some kind of mandala, mandalas of seashell images. It takes you a minute to realize that there are hundreds of these glowing umbrellas, maybe a thousand. What are you to think of this? On some level it would seem like a dream.

I was standing on the boardwalk the night Shoreline Project took place, and I saw such observers. In most cases their initial reaction was curiosity. . .curiosity that soon, usually after a few questions, gave way to awe.

I kept imagining what Shoreline Project looked like from above. Not just the image from the drones that hovered overhead recording the event, but from a satellite view or some distant planet. I imagined someone viewing it from a distance trying to make sense of it, trying to figure out what it meant. From such a vantage, Shoreline Project would function as a beacon. It would be a pattern of lighted forms moving about, not unlike a grouping of cells under a microscope moving in configurations that suggested some sort of function, or perhaps a message that begs to be decoded.

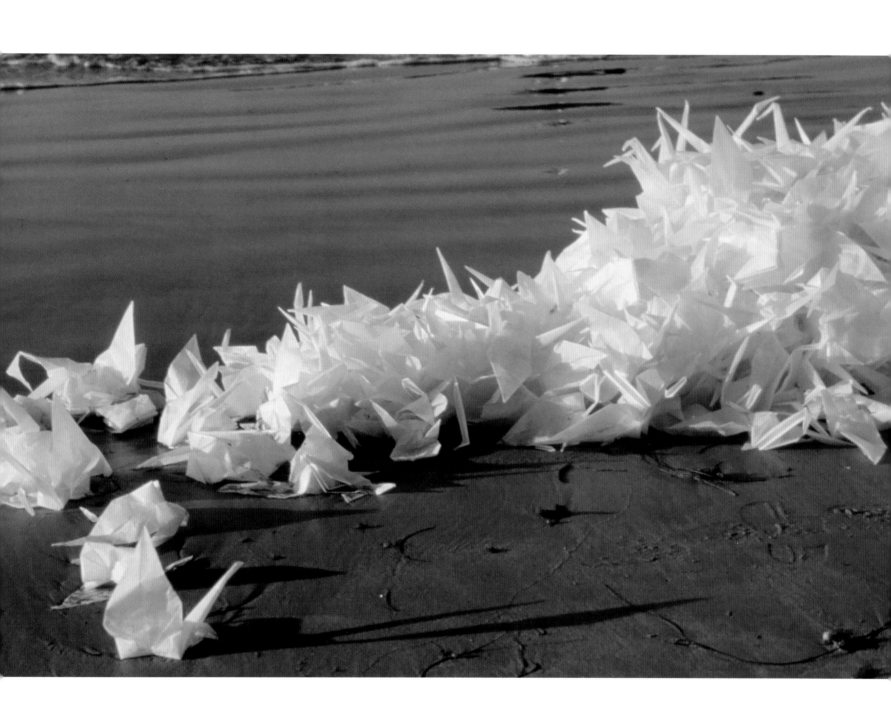

I wonder if this is the kind of experience Laguna Art Museum Director Malcolm Warner had in mind when he conceived of the museum's Art & Nature initiative when he proposed it in 2012. This initiative makes perfect sense for Laguna Art Museum. The museum is a stone's throw from the sands of the Pacific Ocean, at the edge of the continental United States. It is an institution that was founded in the early twentieth century by artists who were known for their depiction of nature in the region. And as we turn into the twentieth-first century, concerns about nature and humankind's relationship to it have become existential issues.

Elizabeth Turk is the sixth artist to participate in the Art & Nature Initiative, an annual event accompanied by exhibitions, lectures, workshops, panel discussions, and publications such as this one. Previous artists include Jim Denevan, Laddie John Dill, Lita Albuquerque, Phillip K. Smith III, and Pablo Vargas Lugo. All these artists interpret and riff on nature in formal visual terms. To some extent this is true for Turk, too. But she digs beneath the visual relationships to unearth structural concerns. She is obsessed with the degree to which nature utilizes math and engineering efficiently. She investigates properties of natural materials and asks how they work and wonders why. Increasingly, she is interested in the relationship between different aspects of nature, including the role humans play.

At first blush Shoreline Project might seem like a departure for Turk. She is best known for her meticulously crafted marble sculptures that seemingly defy the limits of the medium. But Shoreline Project is her fifth experience-based project and, in many ways, a culmination of a multitude of threads Turk has pursued throughout her career to discover the significance of human action in relation to the natural world: the shared organizational patterns, perspectives of scale and vantage in discerning meaning, and humility in

releasing control and being present and patient in ritual. Shoreline Project might best be characterized as a homecoming to a place she never really left.

Though Turk has lived in New York, where she continues to maintain a residence, she grew up primarily in Southern California, playing along the coast in Orange County, where beaches and tide pools were once rife with starfish, sea urchins, and shells. She did her undergraduate studies at Scripps College in Claremont, California. There Turk studied international relations and, after earning a bachelor degree in 1983, moved to Washington, DC. In DC, her career took a turn. Her interest in art was ignited by visiting the museums in the capital and she returned to school, earning an MFA from the Rinehart School of Sculpture at the Maryland Institute College of Art in Baltimore. Today, surrounded by nature, she resides in a home and studio overlooking Newport Beach's breathtakingly scenic Back Bay, a little-known pristine eco-sanctuary. Her larger studio, the place where she carves her marble sculptures, is in a commercial marble yard in downtown Santa Ana. The influences of both coasts are woven into her work.

Six years after her move to New York, planes flew into the World Trade Center. As anyone who was in the city at the time can tell you, everything stopped. The world had changed. In a city renowned for its frantic pace, people slowed down. For many Americans it was time for pause and reconsideration. Turk wanted out of the chaos and accepted my invitation to a residency at the Cal State Fullerton Grand Central Art Center in Santa Ana. As she told me, "Coming home to California was an overwhelming desire. I sought a new vocabulary. Human interaction had little dignity at that moment and submerging in nature felt like the most authentic action.

The Pacific Ocean was home and maybe it would help me set a new direction."

She began having regular phone conversations with a friend from college, Japanese artist Kirara Kawachi. They talked about war and conflict. They talked about WWII—especially, Hiroshima and the pain and scars of those catastrophic events shaping generational memories. They talked about cultural trauma and the healing process. Creating a project that could reconcile such wounds, at least as a first step, became their focus. Turk asked if Kawachi could join her as a co-artist-in-residence at the Grand Central Art Center. "Living, working and sharing all aspects of daily life not only artistic ideas, was integral to our vision and Grand Central Art Center was essential in providing this foundation. The project required collaboration with the core material for the film shorts of Crane Project. Exposing intimate cultural interpretations genuinely was our challenge."

In Japan the crane bird symbolizes happiness, longevity, and future peace. Performing a ritual for healing, Turk and Kawachi began folding a thousand origami cranes out of the lightly waxed paper sheets they bought from a local Santa Ana tortilla factory. The paper cranes became their metaphor for the thousands of mechanical cranes that lined the pier (located at the end of Turk's street in NYC) holding the Twin Towers remains after 9/11. At the Grand Central Art Center they lofted the paper cranes from the mezzanine toward the floor below, watching them take flight and float downward. They also filmed the paper cranes at the edge of the Pacific Ocean, allowing them to float and bob, naturally dispersing as the currents pulled them toward Japan. Separately, Turk and Kawachi each edited two short films using the identical footage they had created together. These short films were presented side by side in the Japan Bank Building in Hiroshima the following year. Crane Project was a platform revealing deeply held, perhaps subconscious, cultural commonalities and differences. The project was recognized in Japan and was awarded a L'Oréal Art and Science Prize in 2003.

The years 2010 and 2011 were significant years for Turk. After a series of residencies, she received a Barnett and Annalee Newman Foundation Fellowship in 2010 and, later that year, a John D. and Catherine T. MacArthur Foundation Fellowship. In 2011 Turk participated in the Smithsonian Artist Research Fellowship (SARF) at the Smithsonian Institution. There, inside the National Museum of Natural History, she investigated the extensive holdings like a kid in a candy store. She had collected seashells as a child and now was given access to both a treasure trove of specimens and the latest image-making technology. Turk was free to examine the composition of their conchology collection. A product of this research is an extensive collection of X-ray shell images, which have

been the foundation for her manipulated mandala images. She has reproduced (and exhibited) the mandalas in a number of iterations and exhibitions and adapted the images for use on the umbrellas in the Shoreline Project.

In September 2017 at an open studio exhibition called *ThinkLab LIVE* at SCAPE Gallery in Corona del Mar, California, Turk presented hundreds of her drawings and preliminary sketches. Next, she and her team conducted dozens of studies testing LED arcs at sunset, determining the appropriate lumens for each umbrella to be seen and filmed by drones. One thousand umbrellas were then fabricated in London. Forming ET Studios as a nonprofit in order to raise the necessary funds, her team began developing and coordinating more than a thousand volunteers, a process that included working with Orange County dance schools and troupes, a classical cellist, and the Laguna drum circle.

On November 3, 2018, Shoreline Project was set in motion, documented with two drones, two photographers, and two videographers—a complex process that Turk monitored from a hotel suite overlooking the main beach. Shoreline Project was conceived, planned, and envisioned over a two-year-long period to be an intentionally organic spectacle created by participants. The project brought her obsession with process and collaboration to a crescendo. Turk said she felt ". . .miraculously set free, I had to let go. That was the magic. Everyone who participated became the artists."

What Turk achieved was a multimedia artwork that functions on numerous levels and lives on in multiple iterations including video, photography, performance, community engagement, physical artifacts, and the memories of participants and observers. It is a

complex entity that can be interpreted from a myriad of perspectives. It is about light's capacity to convey energy and how that can be structured. It is about the functional and communicative properties of shapes and forms. It is about the power of patterns and systems. It is about divergent lines of communication coming together to form community and joy.

No matter where you viewed it from then or how you may encounter it now, Shoreline Project was and is *beautiful*. Beauty is a tricky thing these days, particularly in the art world. The modernists spent a great deal of energy attacking Western ideals of beauty. Postmodernism was largely about breaking down definitions, and beauty was no exception. Today, in an era that is widely defined by cynicism, old notions such as beauty are easy to rebuke and difficult to achieve with any authenticity. This is a challenge Turk has taken on throughout her career. Science may have the last say here: Although the results are still preliminary, an increasing number of studies in recent years indicate that the same area in the brain "lights up" in all humans when they view beautiful patterns or images. In any event, Shoreline Project, like everything Turk has created throughout her career, is beautiful. The umbrella imagery, individually and collectively—especially viewed from above—is stunning.

Turk's choice of the umbrella for Shoreline Project invites a range of interpretations, for the umbrella has a rich history and symbolic ripeness. Umbrellas were first developed about three thousand years ago by the Egyptians as a shield against the sun. The Chinese later developed a leather version to repel rain. In Buddhism, the umbrella can represent a portable temple. In the UK there is a saying that "a banker will only lend you an umbrella if the sun is out." In some dream analysis texts, the umbrella can be a forewarning of something chaotic or threatening. It has also functioned as a symbol of wealth or power, something carried by or for aristocrats. In

2014, umbrellas were used in Hong Kong to shield human-rights protesters from pepper spray in what came to be known as the Umbrella Movement. At times, in ancient Greece, for instance, the umbrella was seen as something only women would use. The overriding essence of the umbrella, though, is that it is a device used to protect.

When I think of umbrellas and art, the first images that come to mind are Christo and Jeanne-Claude's *The Umbrellas* project of 1984-1991, which, after almost a decade of planning, placed more than 1,500 yellow umbrellas across an area in Southern California and 1,500 blue ones in Japan simultaneously. I also think of Rene Magritte's playful depictions of the umbrella.

Christo and Jeanne-Claude's umbrellas were monumental, weighing nearly 500 pounds each and stretching across miles of landscape. Turk's umbrellas are more intimate, personal objects that come together to form an immense configuration when viewed from above. Turk's umbrellas individually and especially collectively are more surreal, more reminiscent of Magritte. But because they are in a public space, they also have an affinity with the surrealists' unrealized plan to collaborate with bakers all over the world and have them inexplicably place thirty-foot-long loaves of bread on the street on the same day. As Turk pondered, "Where is the rationality in 4,000 people coming together on a

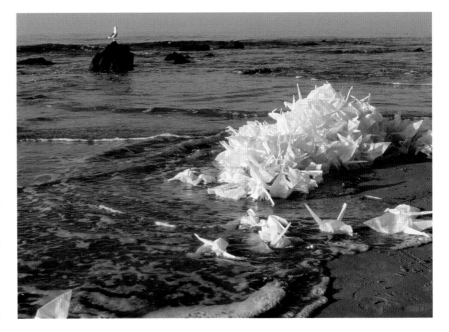

brilliantly sunny day to watch or to carry rain umbrellas on a sandy beach in Southern California, but they did and unexpectedly they found joy and community." I for one think the world would be a better place if there was a bit more surrealism in our day-to-day lives.

As I was standing on the boardwalk watching Shoreline Project unfold, I was struck by the jubilance of the participants. A brief cello performance by Ross Gasworth that began at dawn gave way to a pervasive and continuous tribal rhythm of hands smacking on drums—Laguna's floating drum circle, whose perpetually changing roster of participants has played on the sands of Laguna Beach for decades. In the twilight period came a dance performance by the Southern California-based Assembly Dance Company, choreographed by the company's director, Lara Wilson, soon followed by a series of impromptu performances by other local dance companies throughout the evening. Turk's volunteer participants, a thousand strong, twirled and gestured with their glowing seashell umbrellas. A large crowd of onlookers roamed the area, talking to one another, sharing the experience. Children frolicked in this environment, their usual license to play amplified by the participation of adults.

I spoke to one woman who had planned to come to Shoreline Project with a group of friends from her workplace. She said that it was so liberating to be able to do something with friends and coworkers, to be a part of something fresh and genuine that didn't have an overwrought agenda. It was so gratifying she said, "to be a part of something that was about beauty."

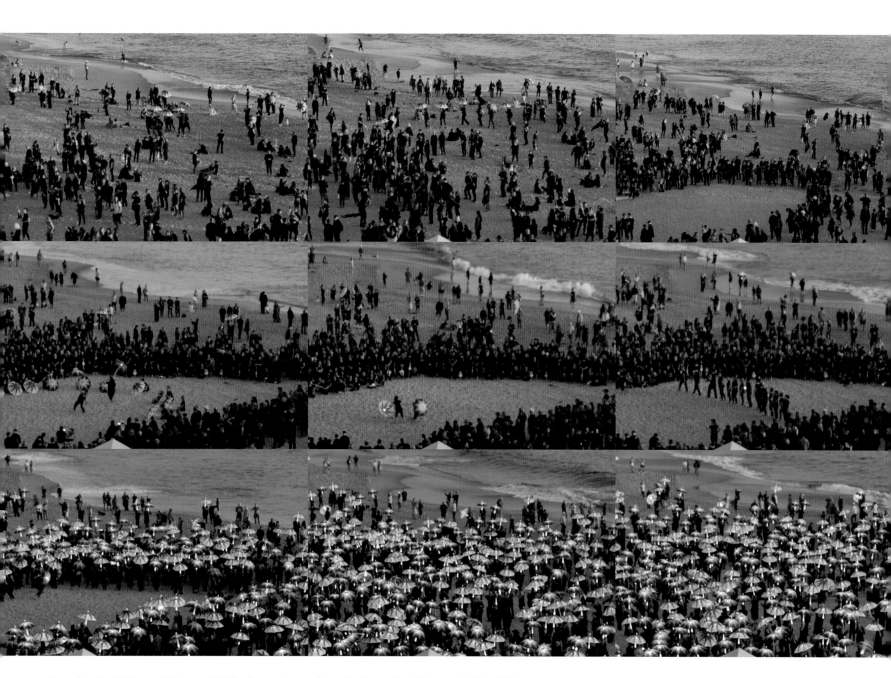

HIDDEN UNDER
THE REVEAL

1000 BECOMES 1 ORGANISM

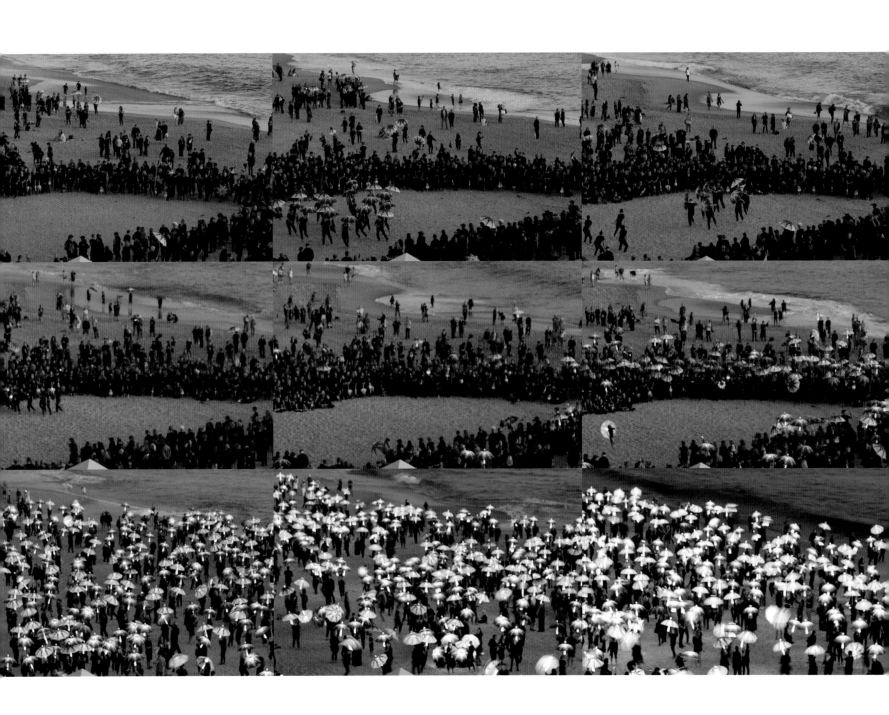

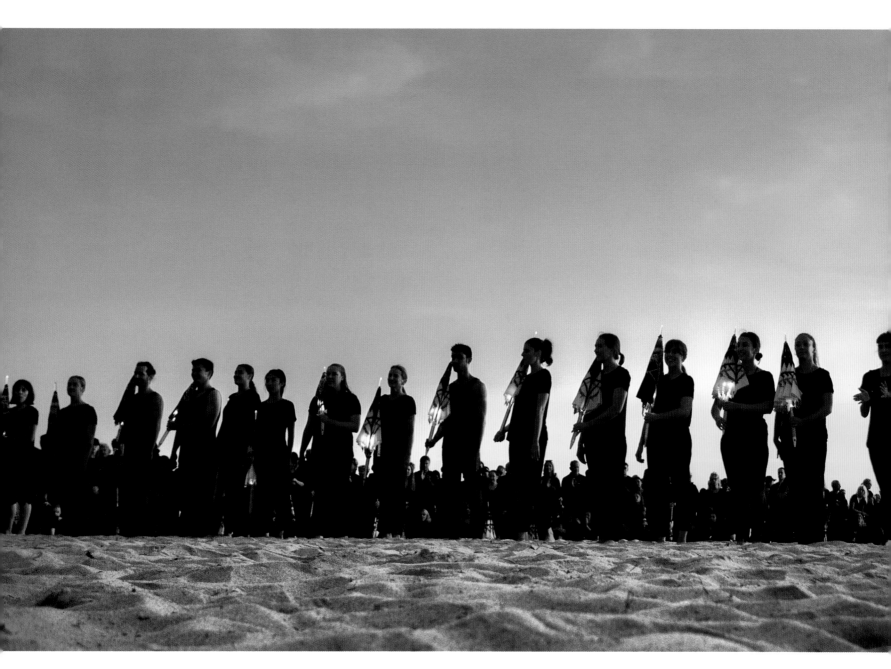

ONE OF A THOUSAND
PERSPECTIVES
MEG LINTON

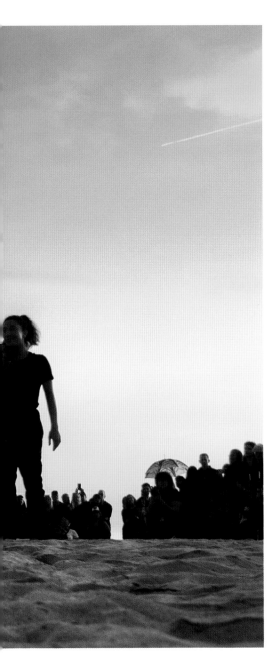

It was a warm, extremely dry, thirsty Saturday afternoon in November as the 1000 or so actors in Elizabeth Turk's Shoreline Project gathered on the beach in droves below the Laguna Art Museum. The light was stark and buttery and accented with a mild ocean breeze. The participants seemed happy to be in their all-black costumes and have their feet in the sand. The growing din of human voices quickly overcame the sound of waves as the "welcome" chatter increased, with each new group of visitors questioning, What line do we stand in? Did you bring your waiver? How far did you drive? Where did you park? How do you know Elizabeth?

All these queries were enthusiastically answered by a multigenerational team of volunteers, and/or by people standing in line, who passed information along to those newly folding into the ensemble. The moment the clock struck five, the umbrella distribution began. With black-and-white umbrellas in hand, the single-file line evaporated into a playful mass of curiosity.

It was as if no one had ever seen an umbrella before—this ubiquitous portable canopy design dating back to ancient Egypt, Persia, India, China, Italy, and Greece. It was first a protector against sun and, later, rain. The name derives from the Latin "umbra" for shade or

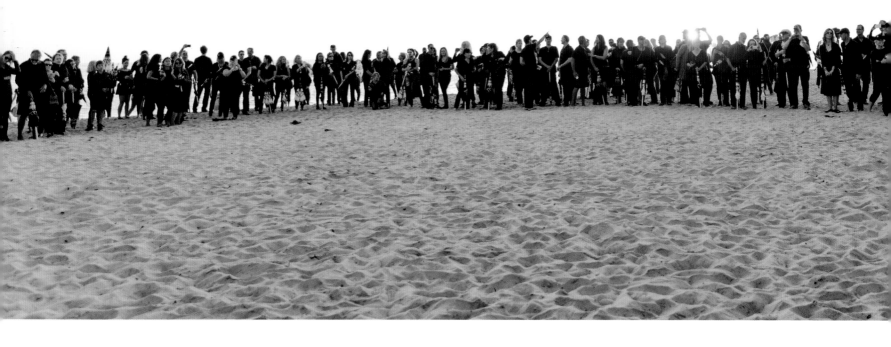

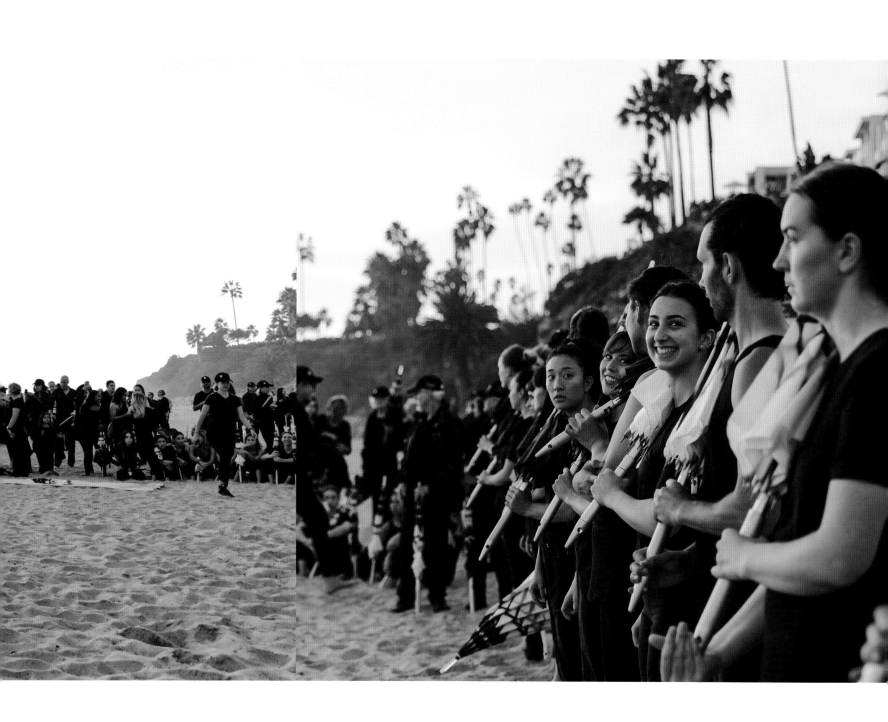

shadow, while "parasol" comes from the French as a shield from the sun. Turk's prop was neither. It is an internally illuminated design emblazoned with an X-ray image taken from her Seashell Mandala series (2014). This Promethean object projects light out into the darkening world and calls forth something ethereal from the sea to the shore or vice versa. And for this semi-choreographed, communal performance turned ritual, it became a tool for "something [that] covers or embraces a broad range of elements or factors."* It momentarily gathered, collected, and unified a community seeking a meaningful connection.

At twilight, from her elevated view on a balcony at the Inn at Laguna Beach, Turk issued commands to her lead actors on the ground to begin. The music rose up and the muted congregation of umbrellas started to sway, twitch, and shimmy. She enlisted the help of professional musicians and dancers to guide and inspire her willing participants through various kinds of movements and actions, from jelly-fishing (opening/closing the umbrella rapidly), to waving up, down and around, to swarming and dispersing. The movement had a central starting point

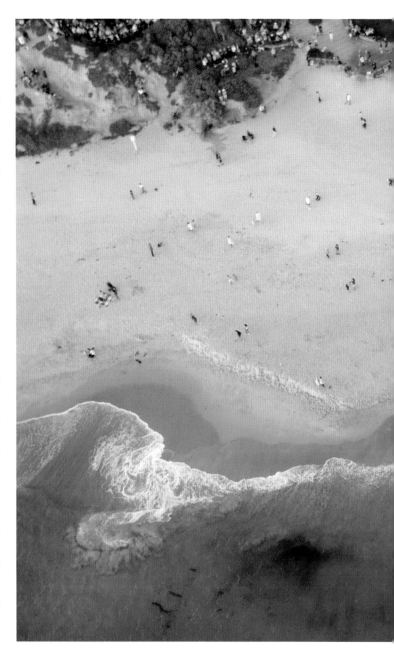

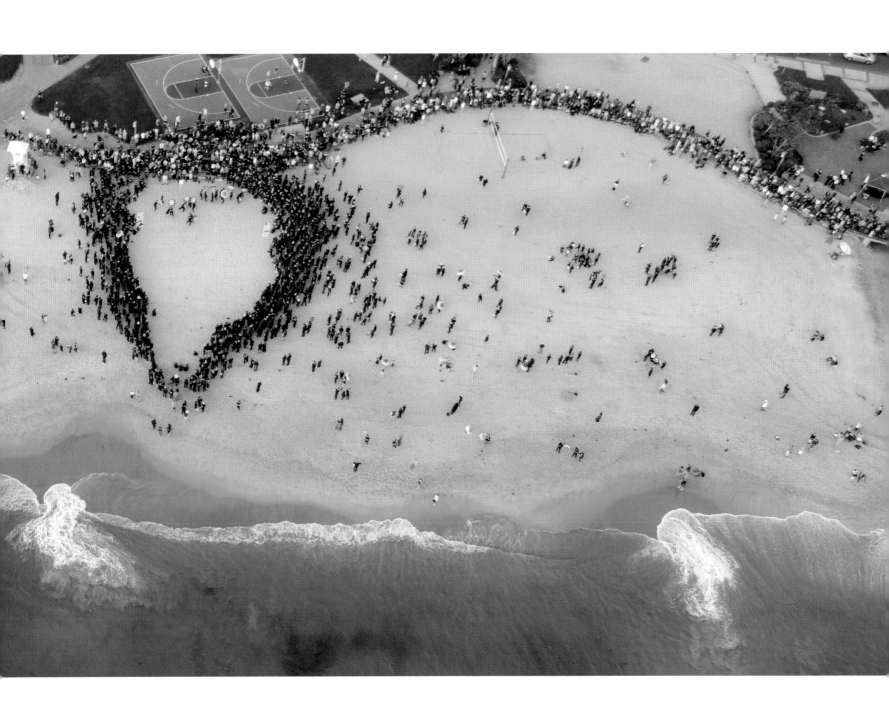

and radiated out through the mass. As soon as the sun dipped below the horizon, the umbrellas lit up on cue and Turk breathed a gleeful and thankful sigh of "Oh! they all turned on!"

Far from the static installation of Christo and Jean-Claude's *The Umbrellas* (1984-1991), this rendition was filled with unpredictability like children playing with sparklers on the 4th of July, and was ultimately at the service of people's whims and musings as they fell in or out of step with the rhythms of the tide, drums, and human voices. For two hours, the whole beach was ablaze with the pulsating mandala starfish/sand-dollar images. Before our eyes and under the buzzing of the drones, it morphed from a performance to a prayer. Was it an action to call forth rain, to heal the earth, or a eulogy to what is disappearing? Every individual who participated or looked on will have a different answer as to the purpose and meaning of this artwork. It was a magical night orchestrated from a desire to celebrate common ground, foster optimism, and relish nature's beauty where the sun and sand meet the sea.

Meg Linton has been a curator and writer in the field of contemporary art for more than twenty years, as the Director of Galleries and Exhibitions at Otis College of Art and Design (2003-2014), Executive Director at Santa Barbara Contemporary Arts Forum (1999-2003), and independently. She is currently CEO of the Newport Beach Public Library Foundation.

*Merriam-Webster Dictionary App. "umbrella" definition as of 4/5/2019.

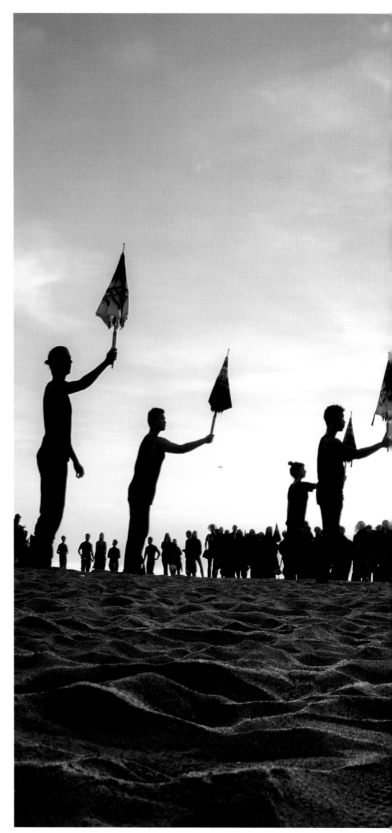

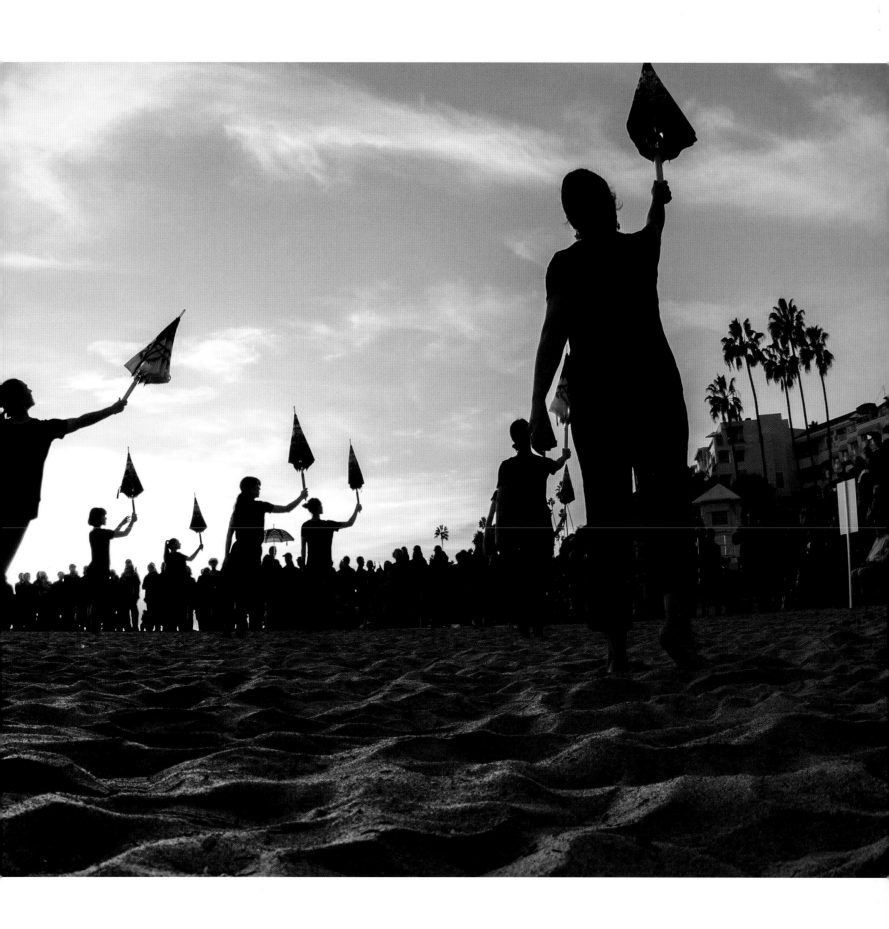

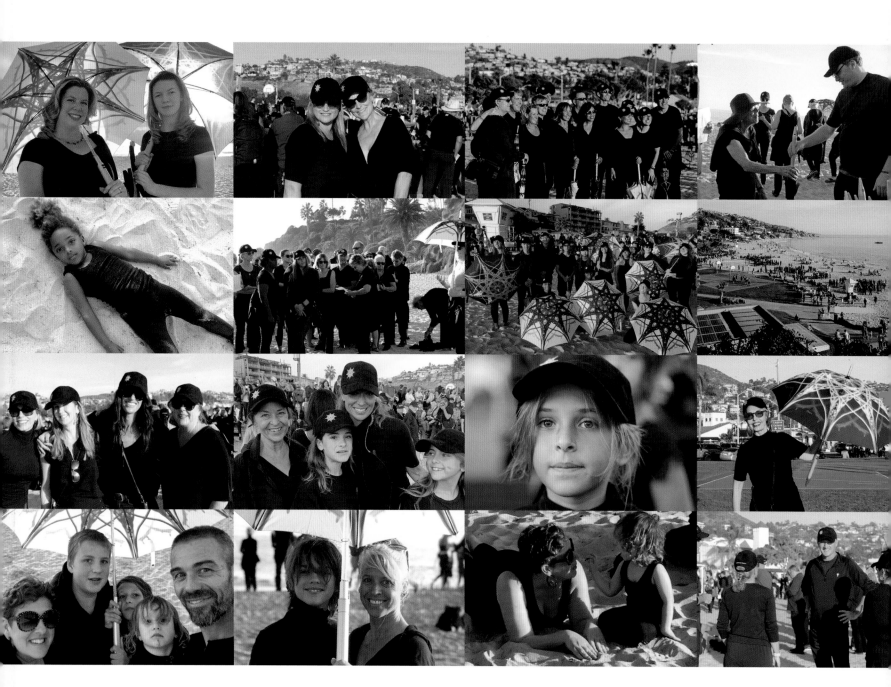

SOUND

DRUMS, THE HEARTBEAT OF THE OCEAN

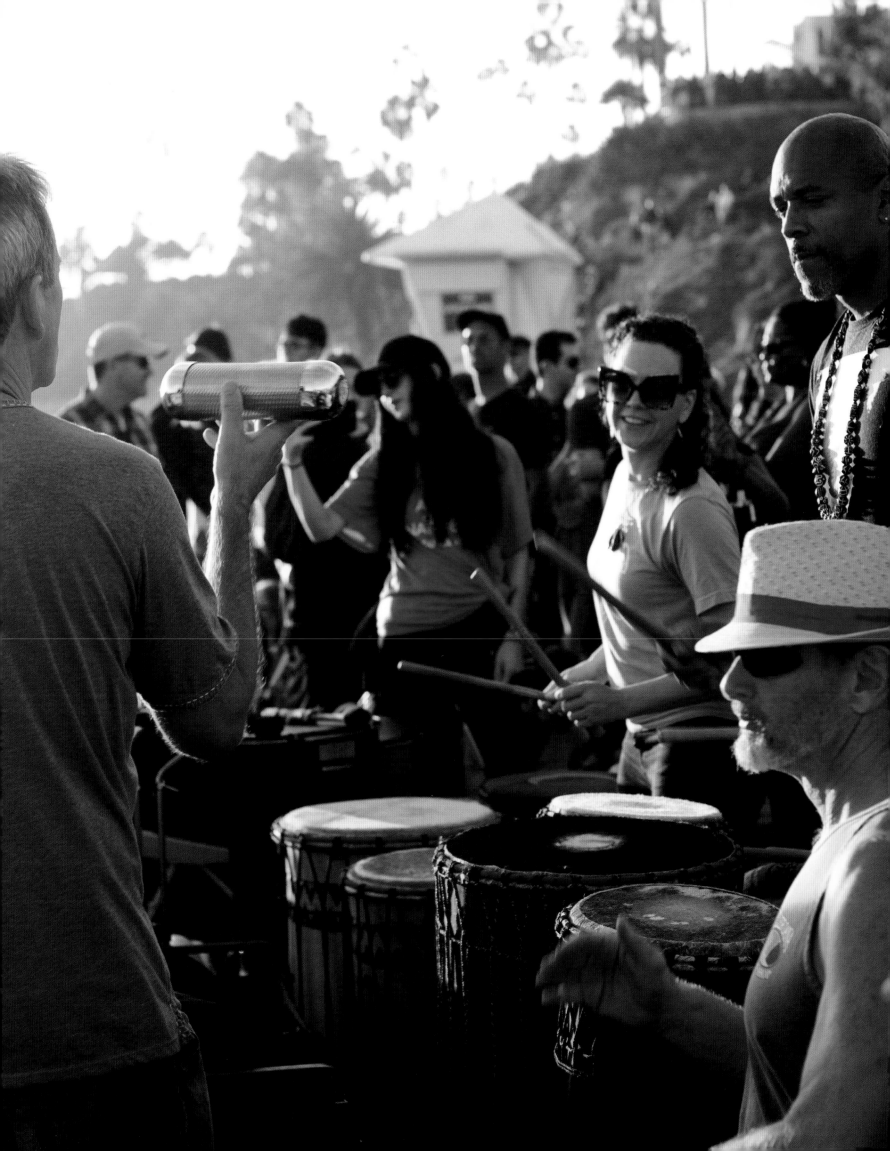

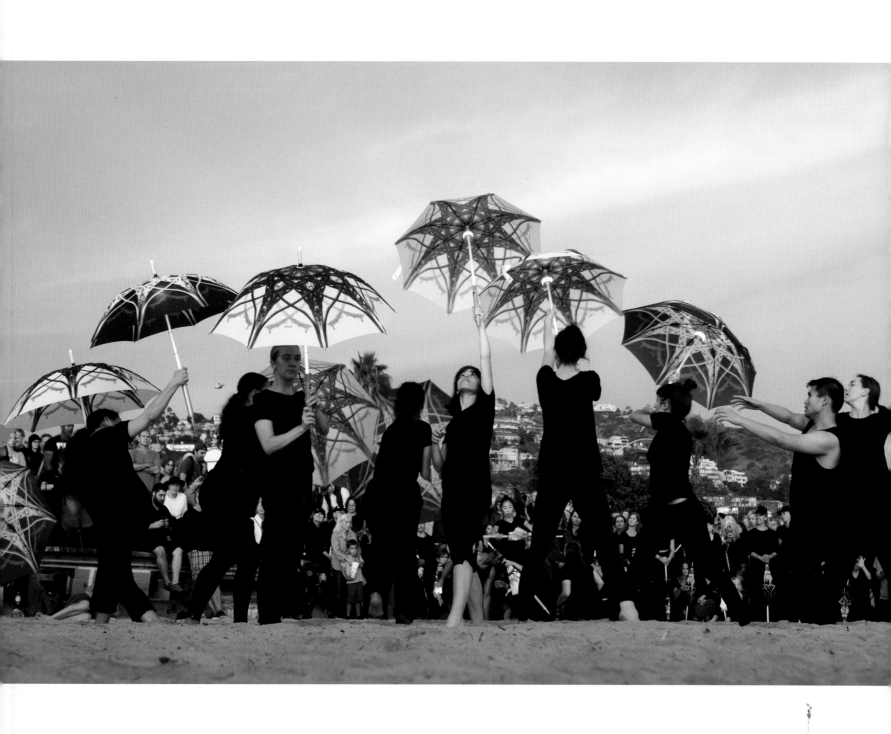

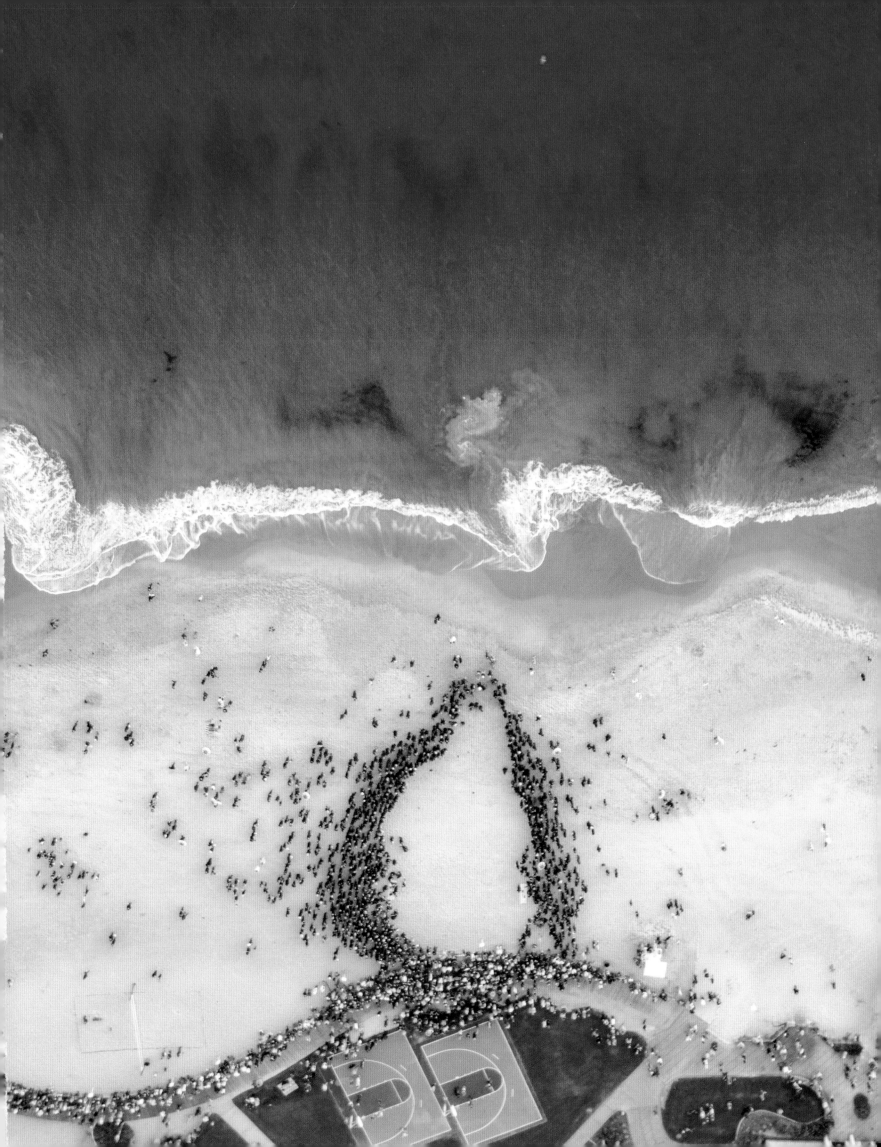

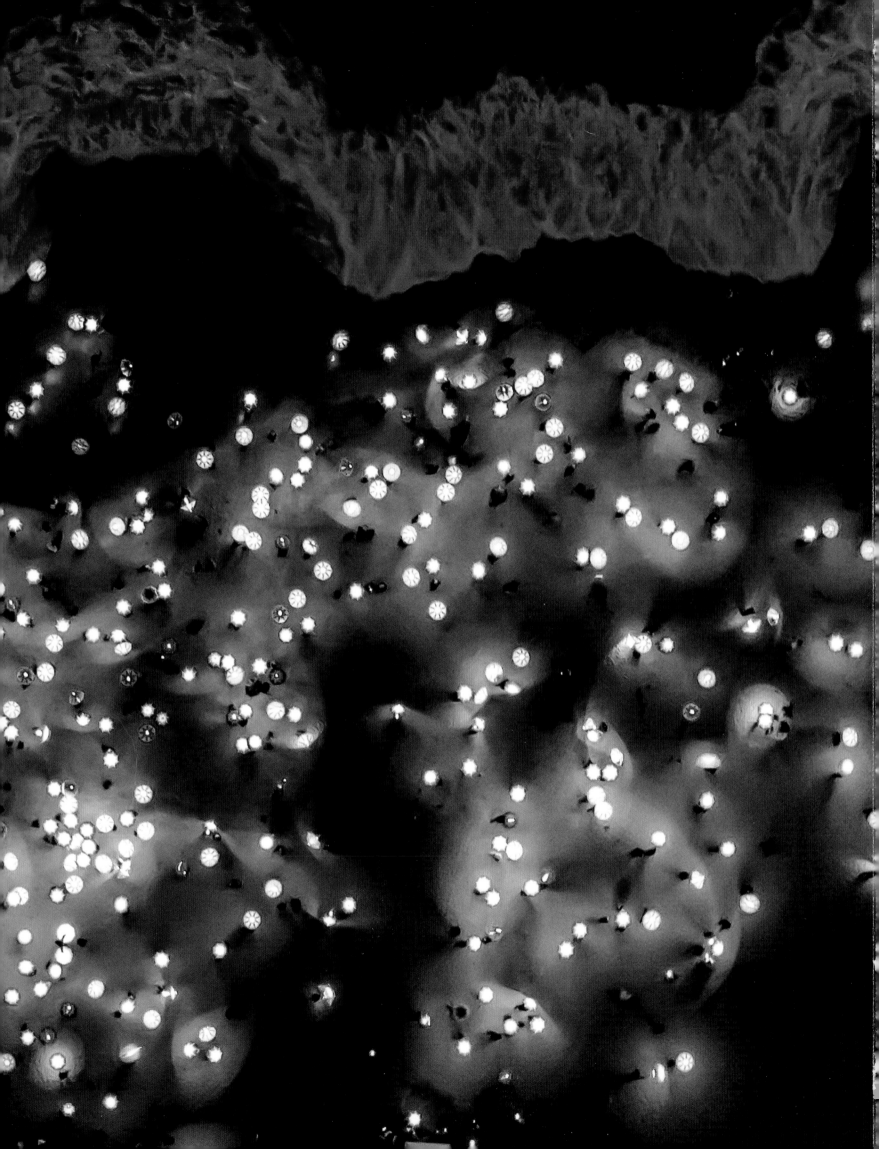

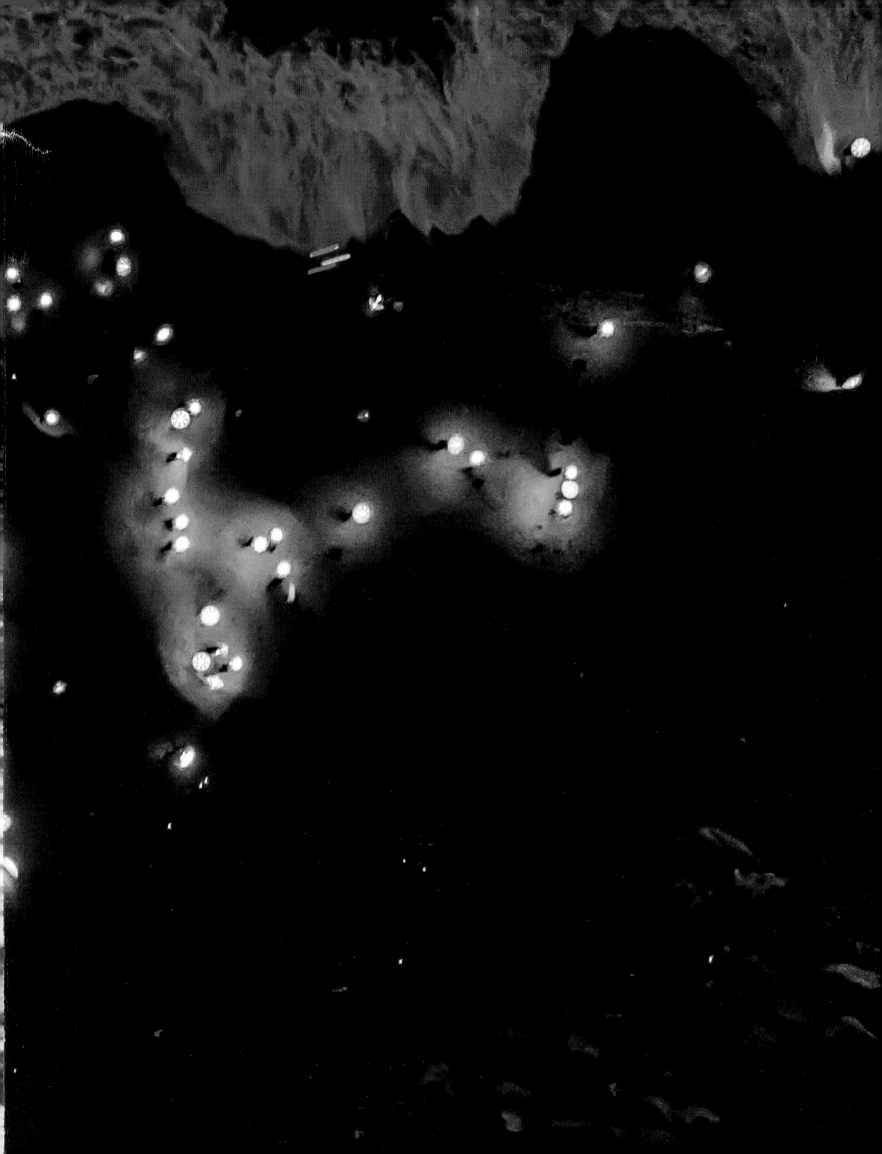

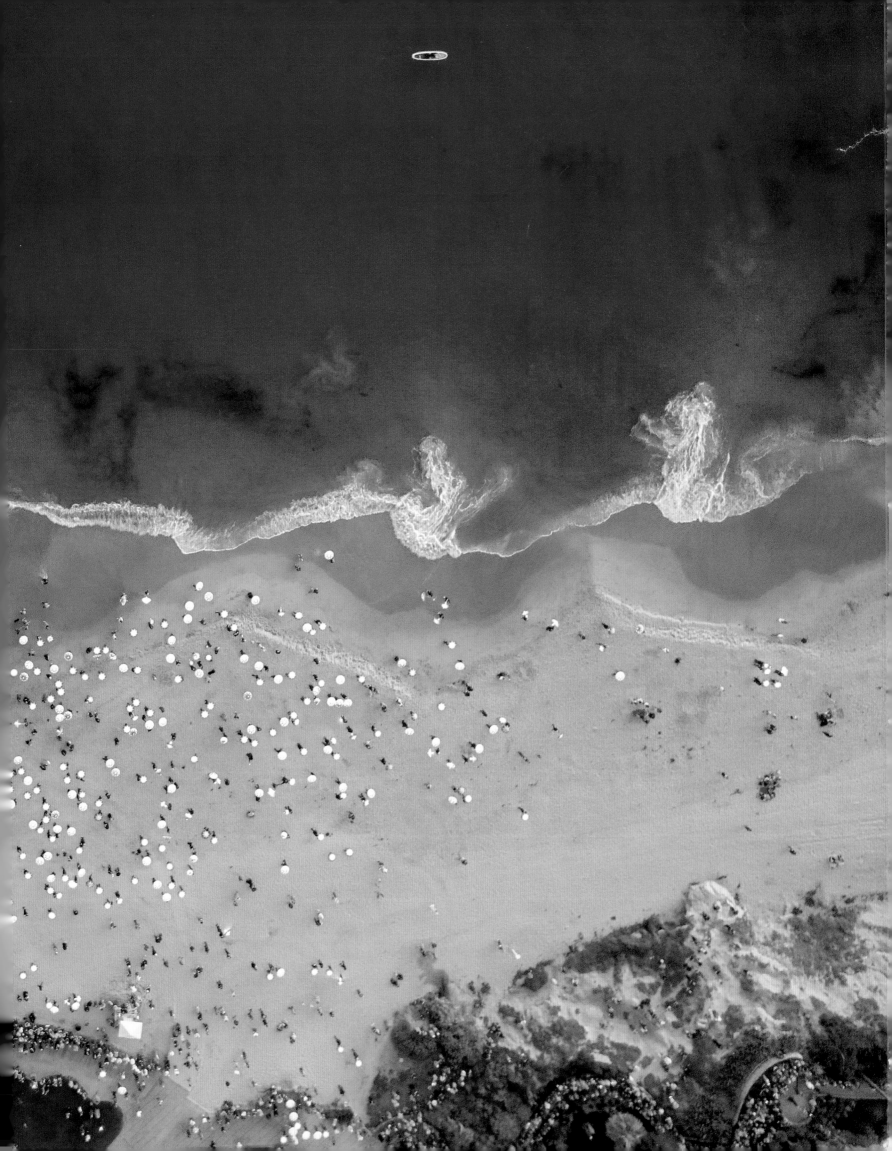

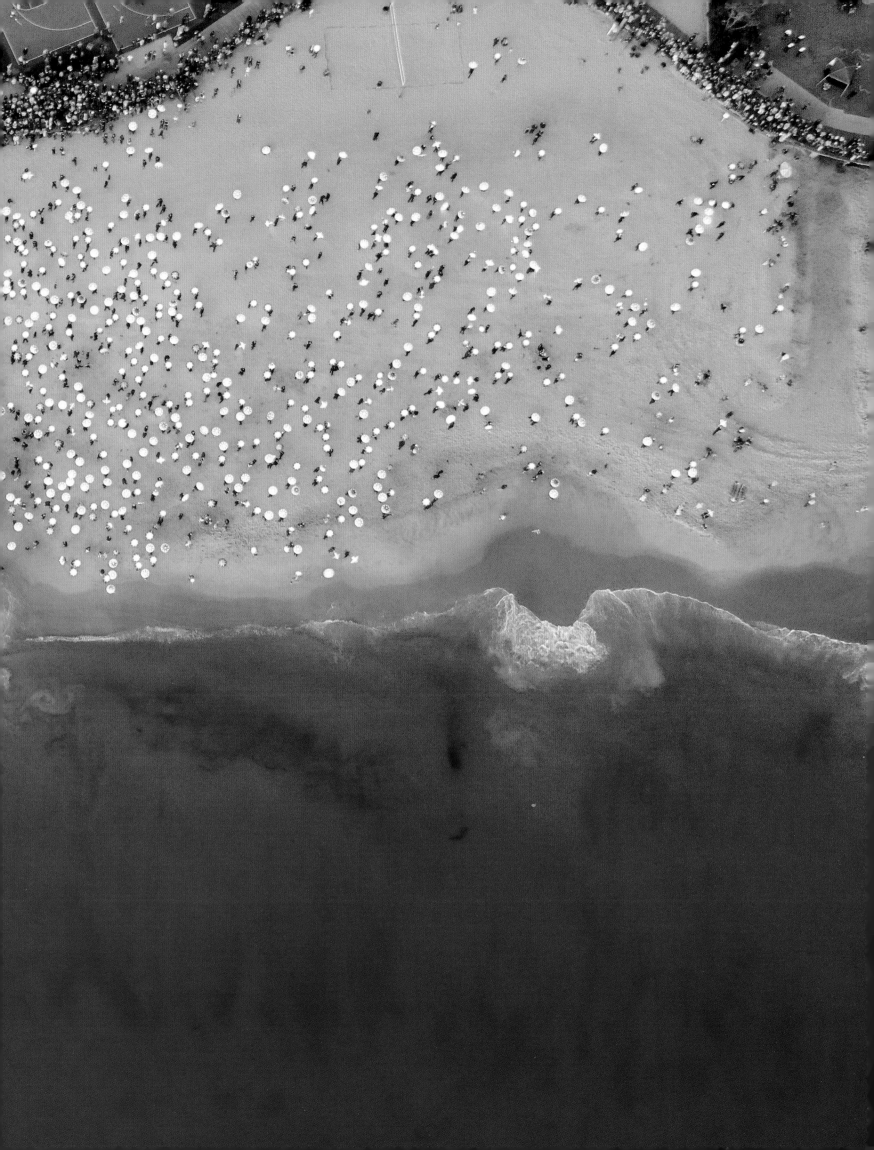

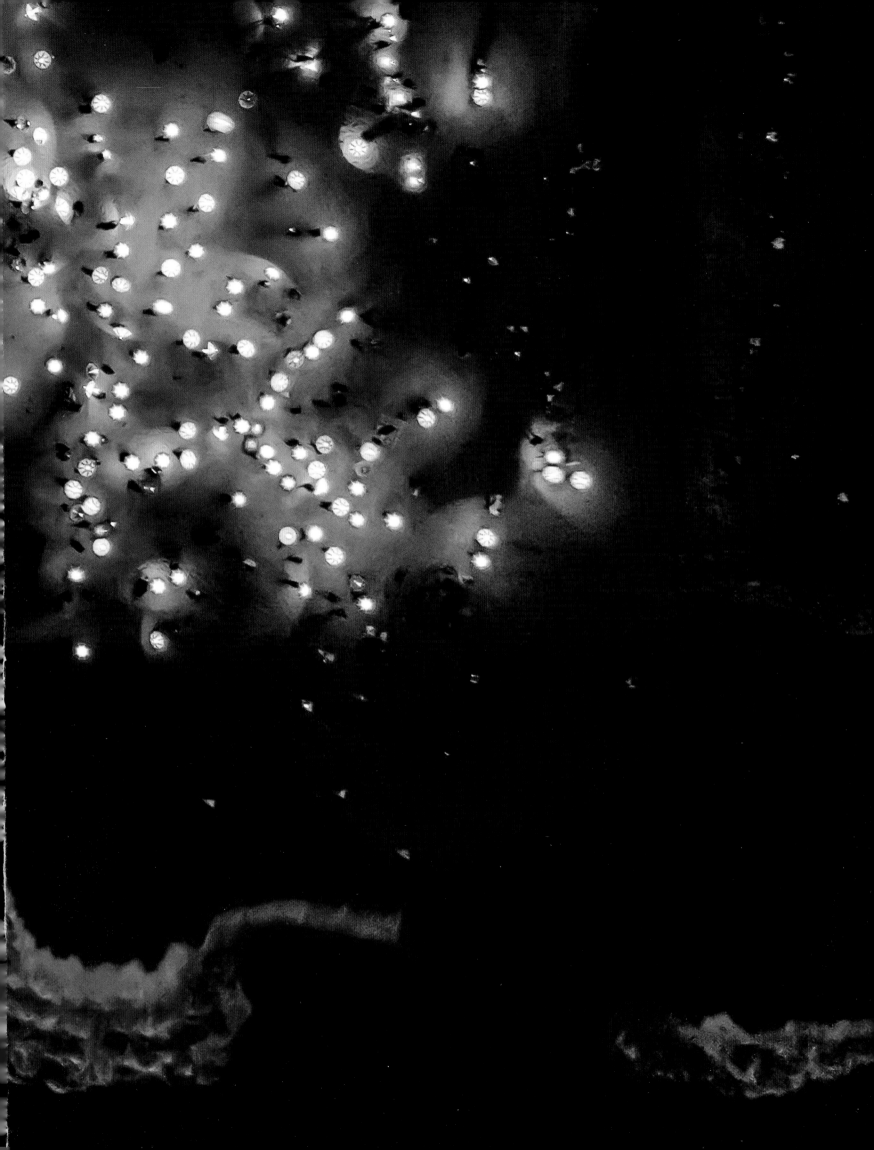

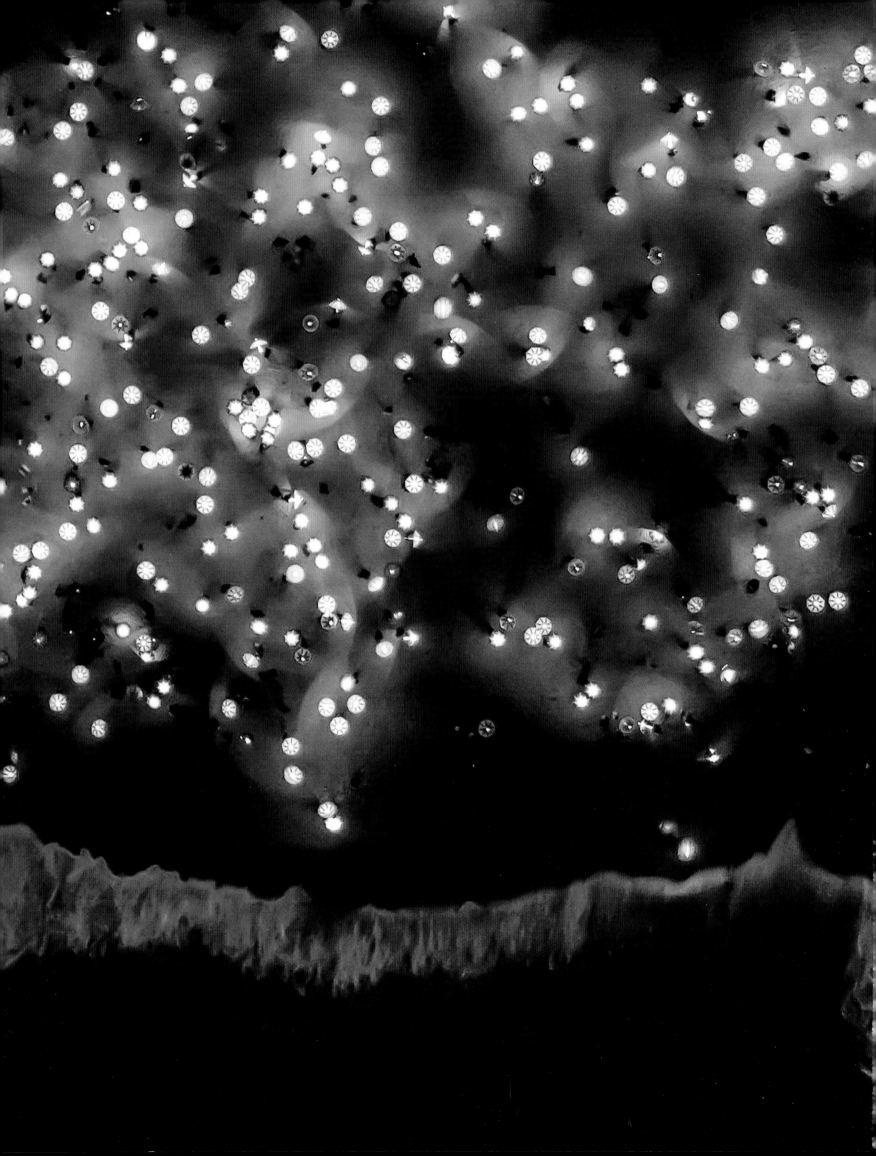

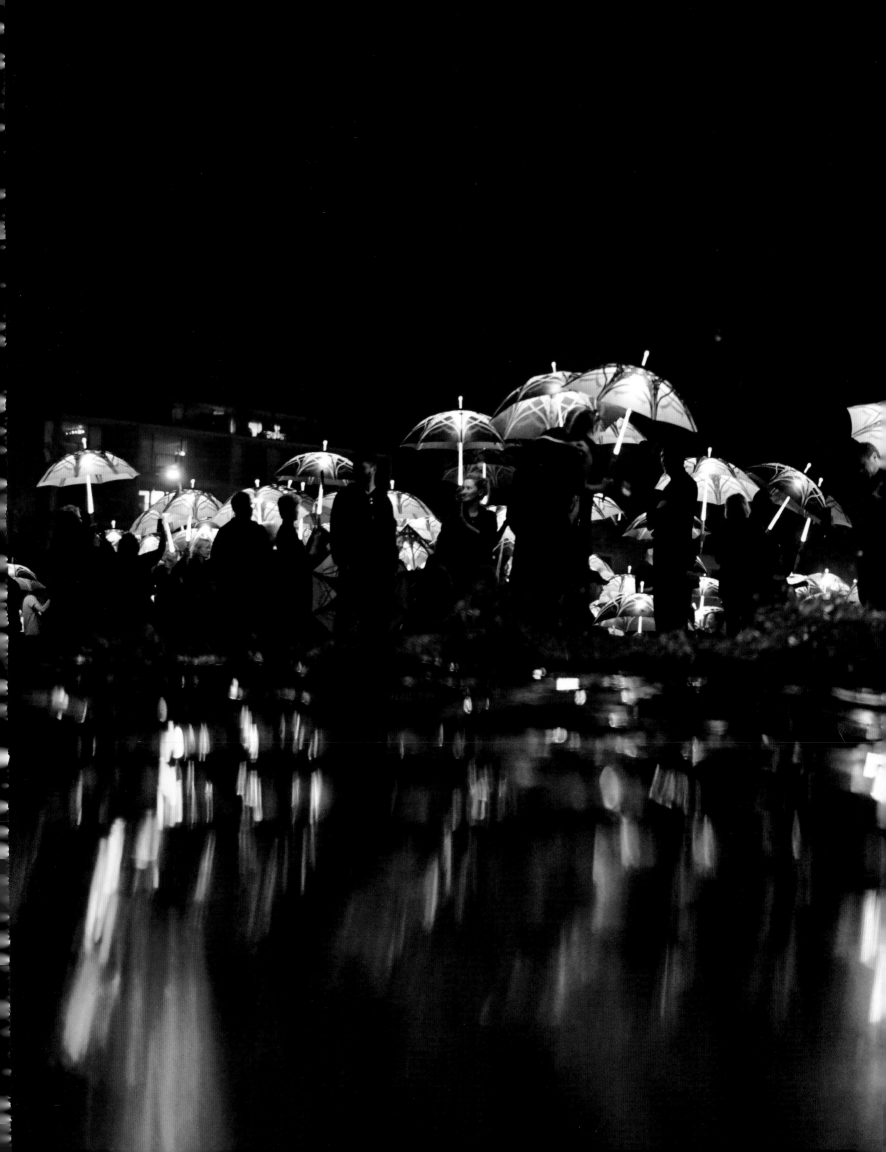

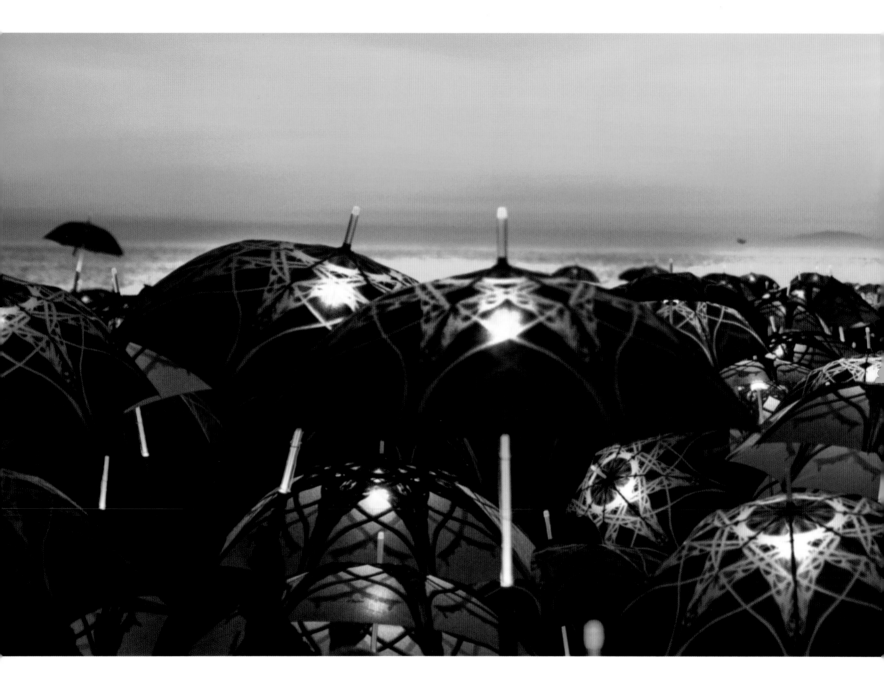

SUNSET

5:56 P.M. / TIDE 4.62" / NOVEMBER 3, 2018

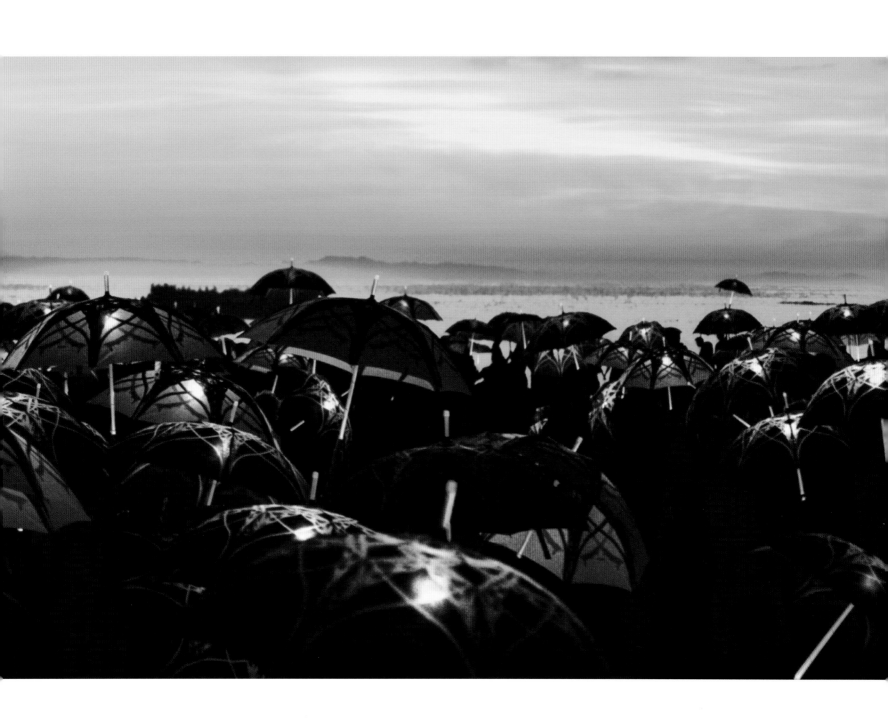

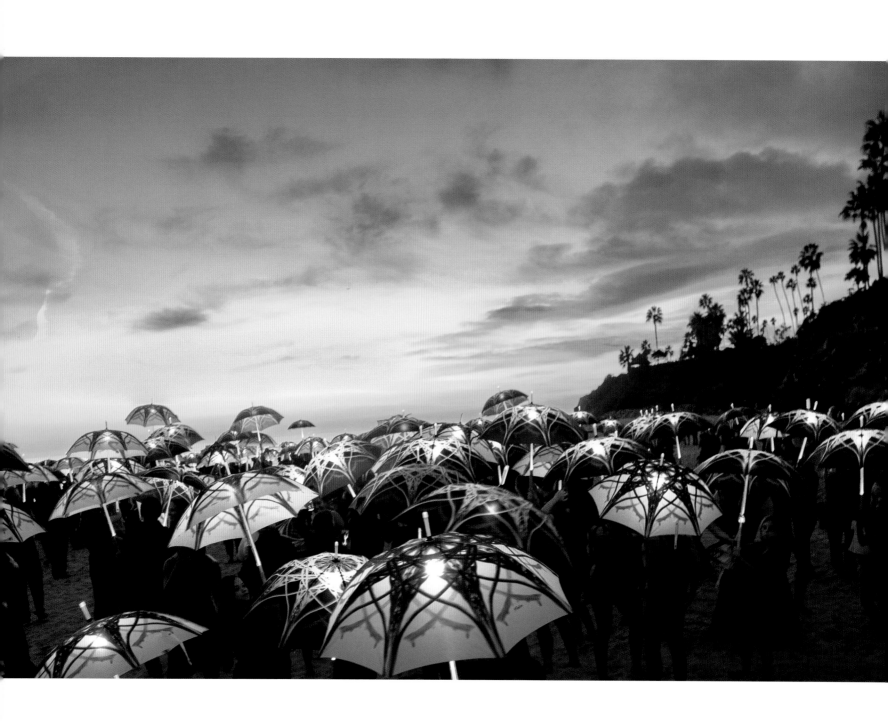

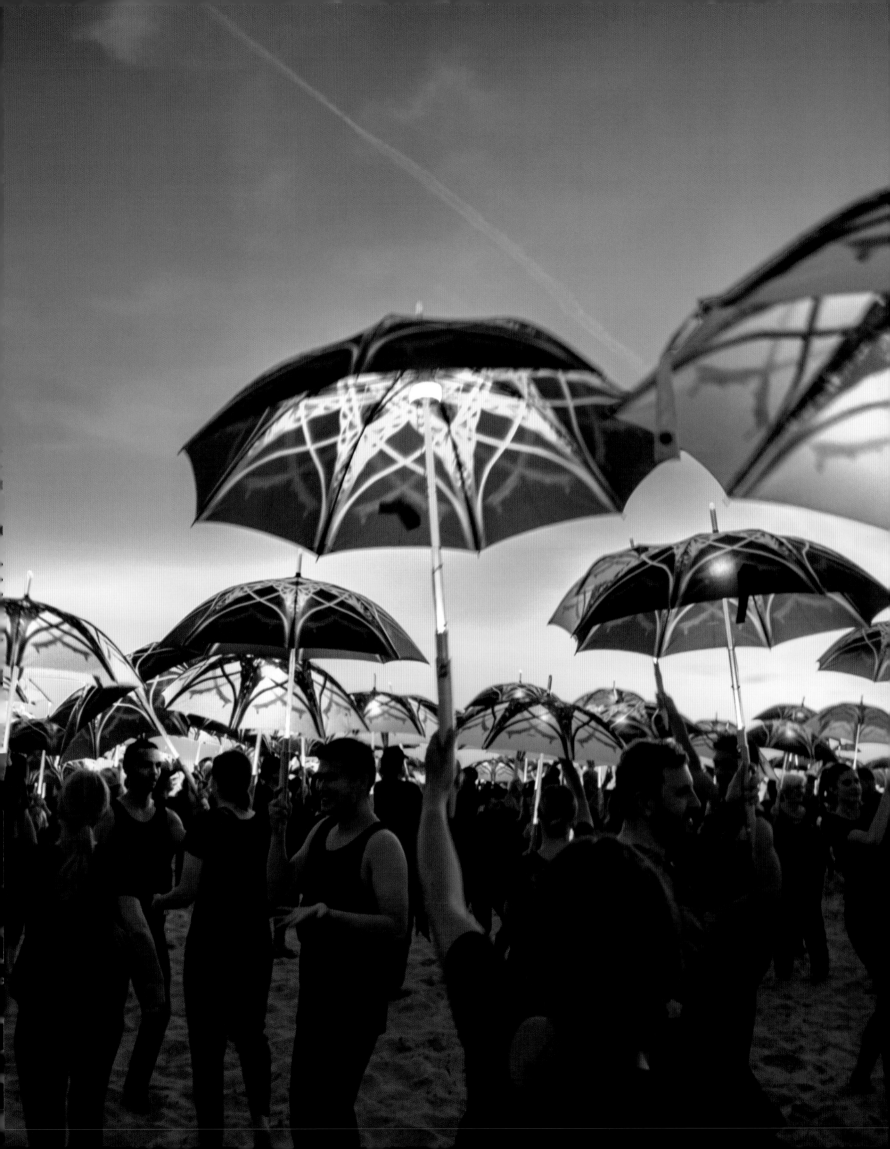

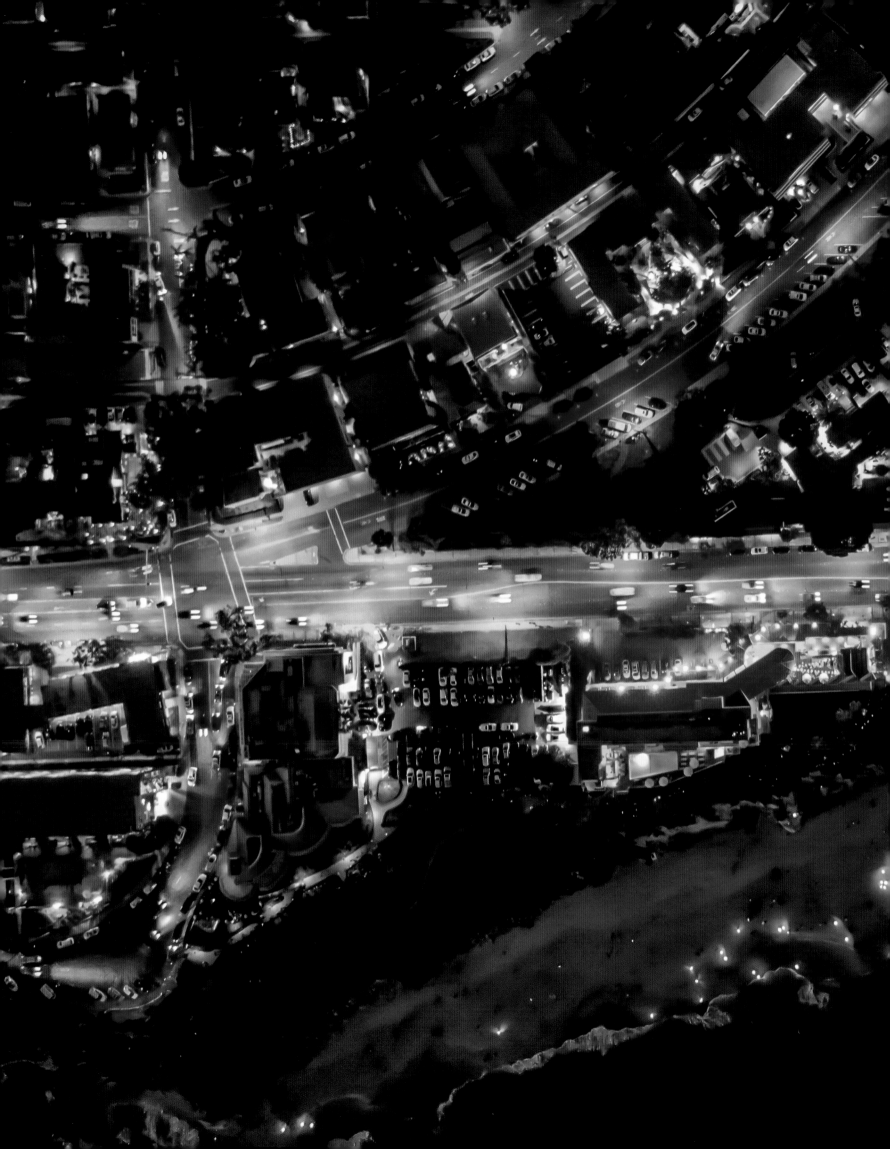

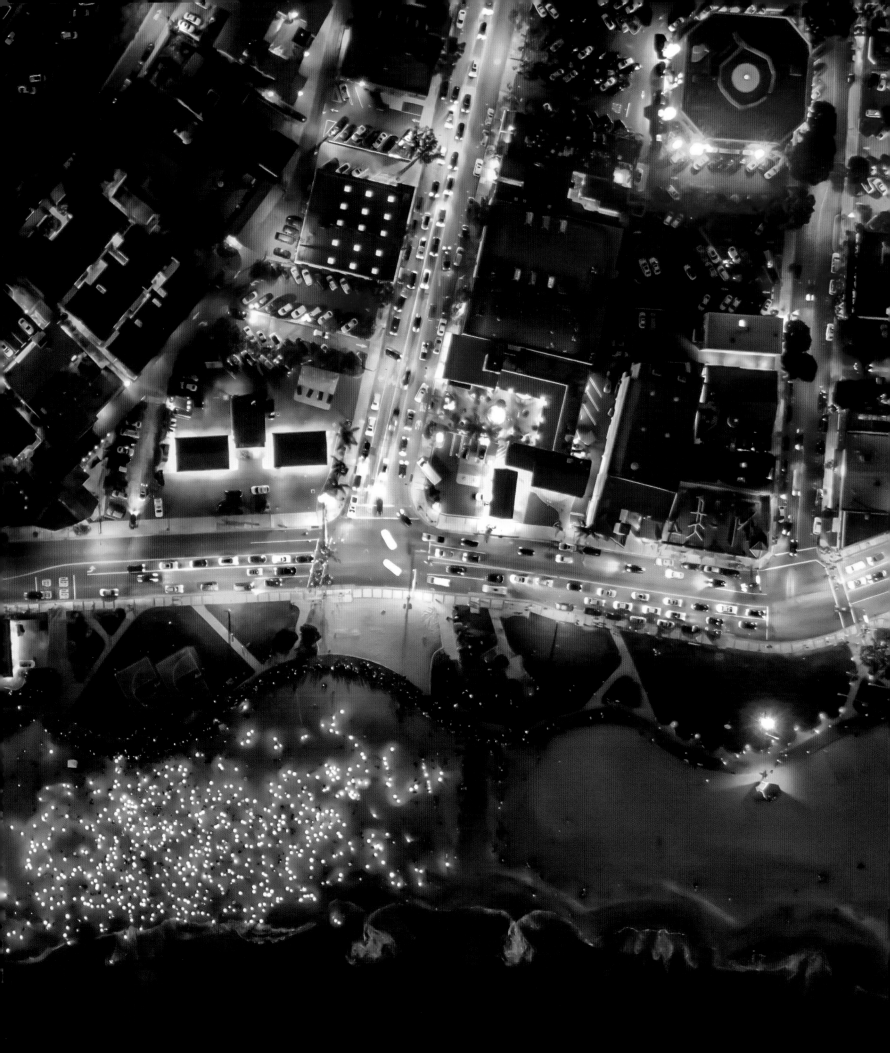

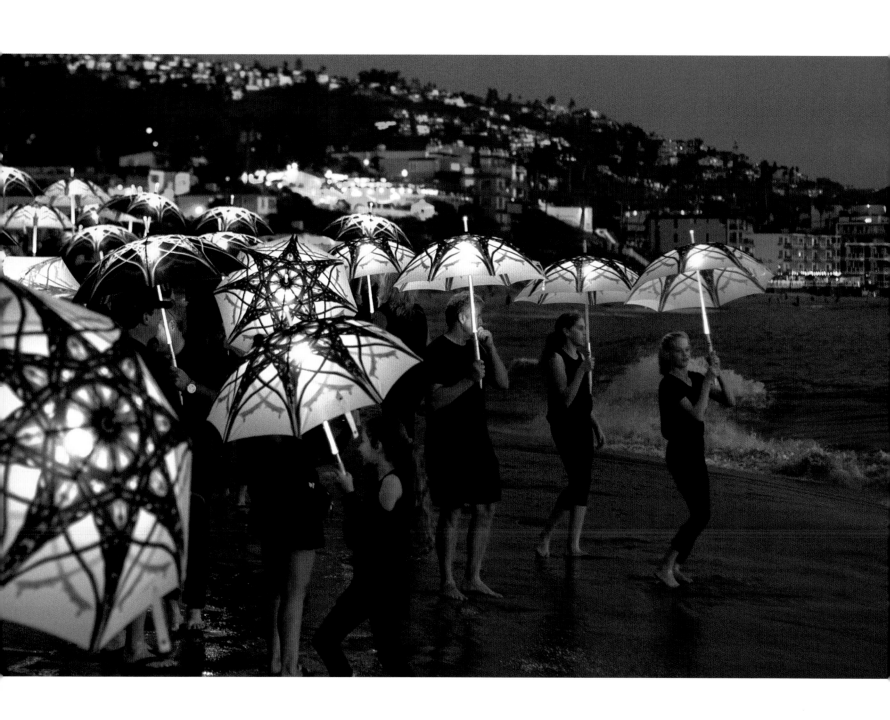

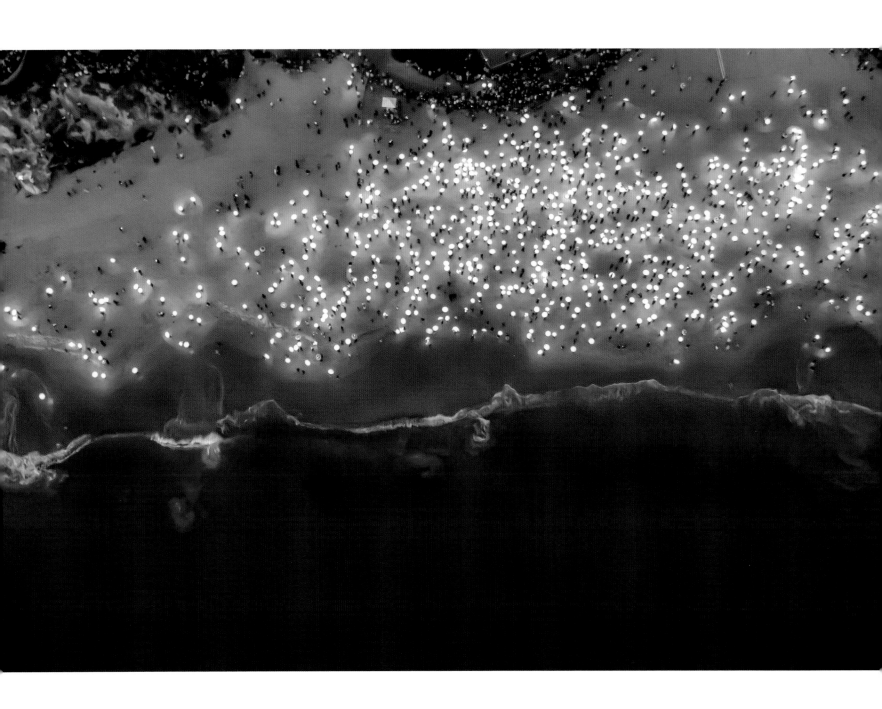

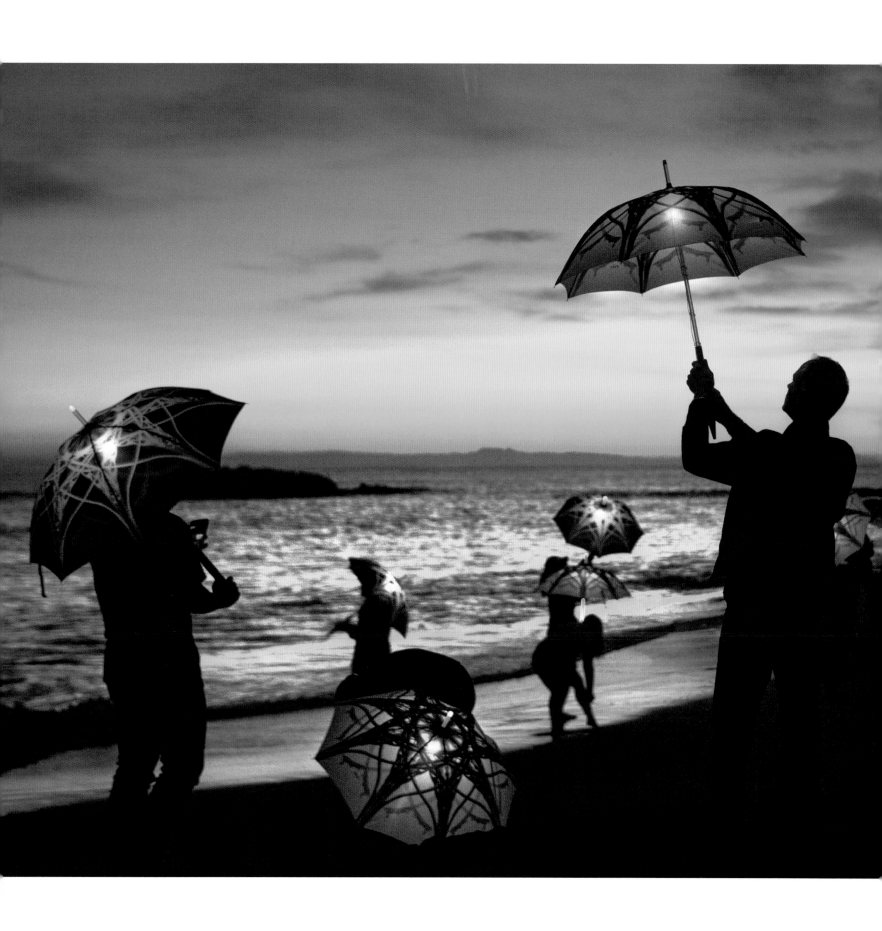

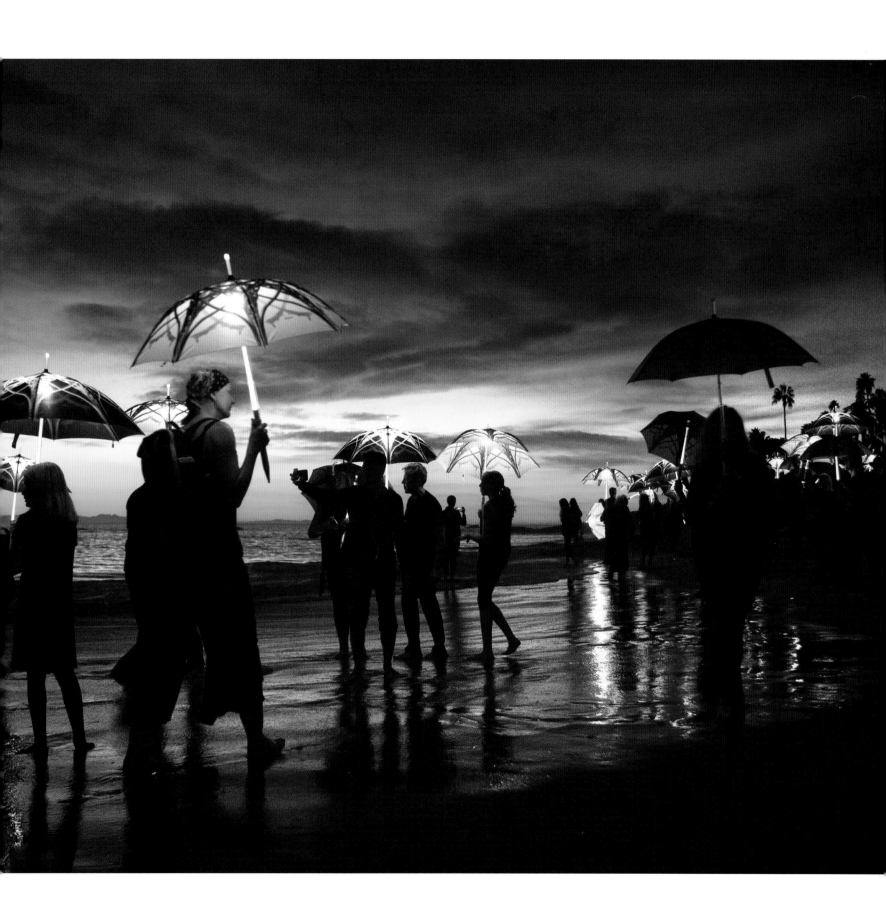

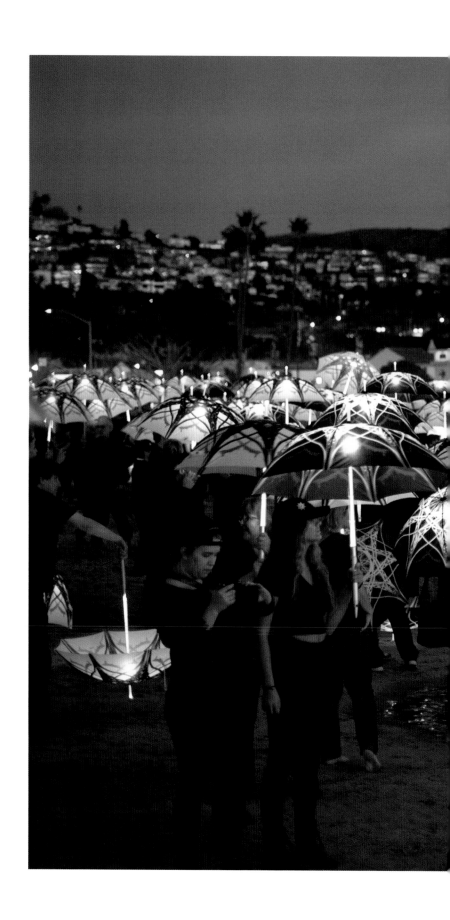

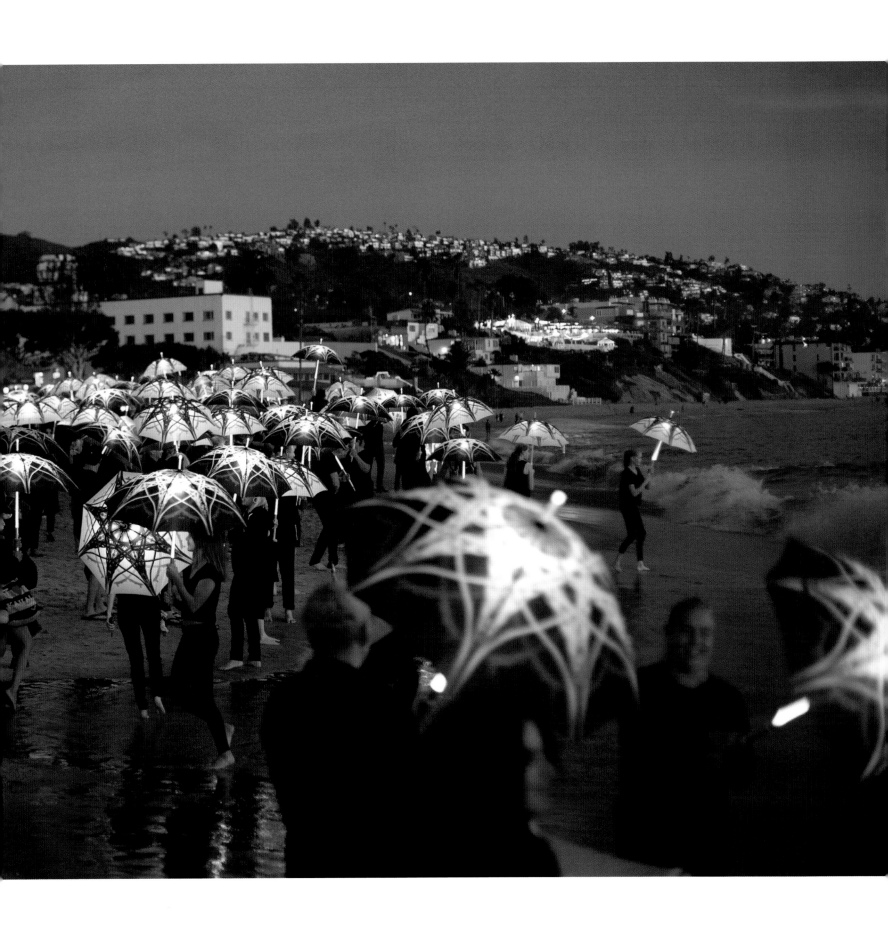

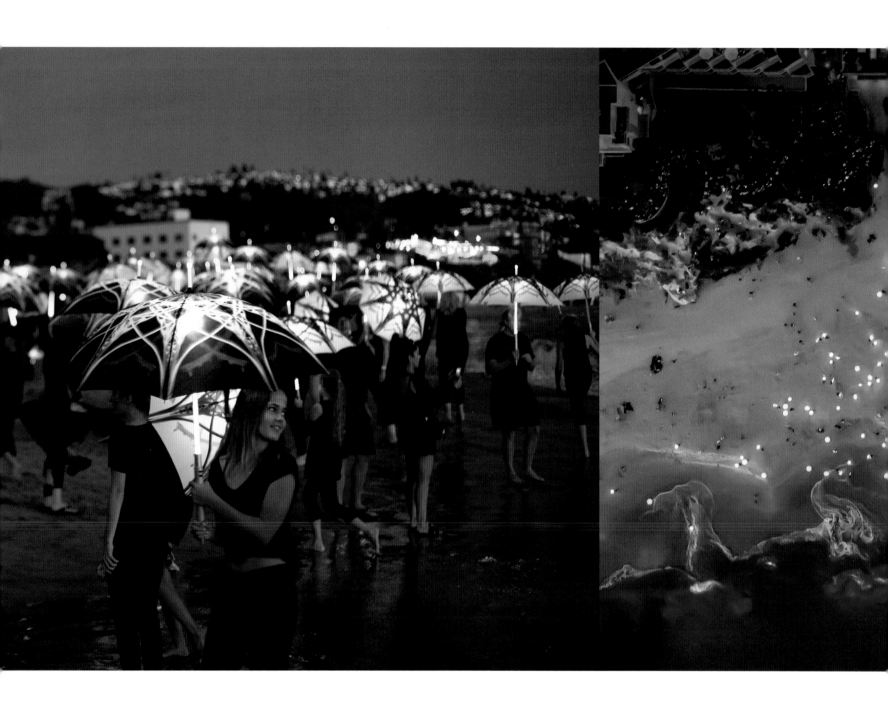

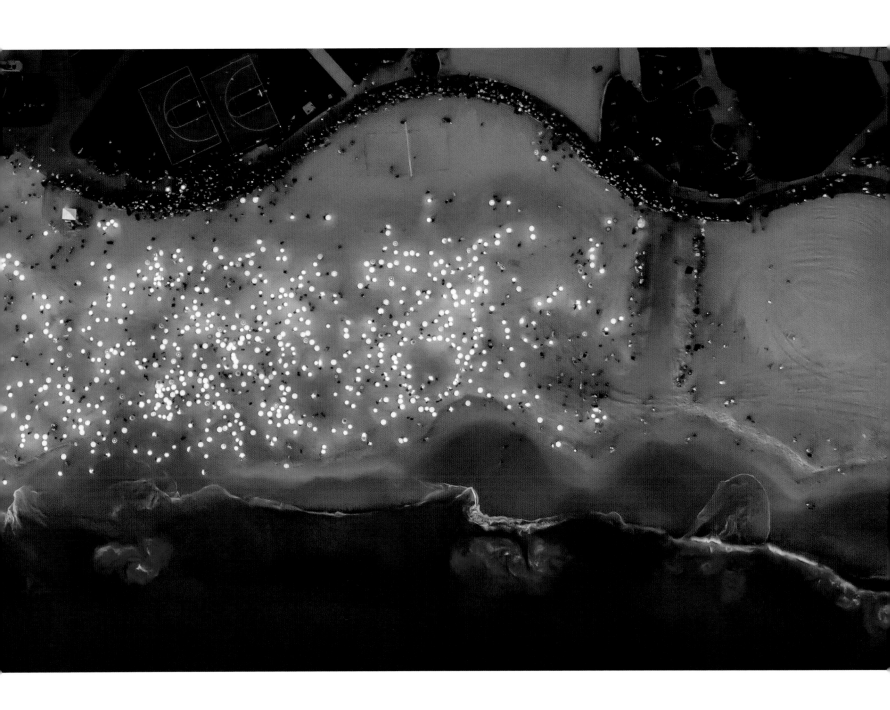

DARKNESS REVEALS A COMMUNITY AS ONE ORGANISM

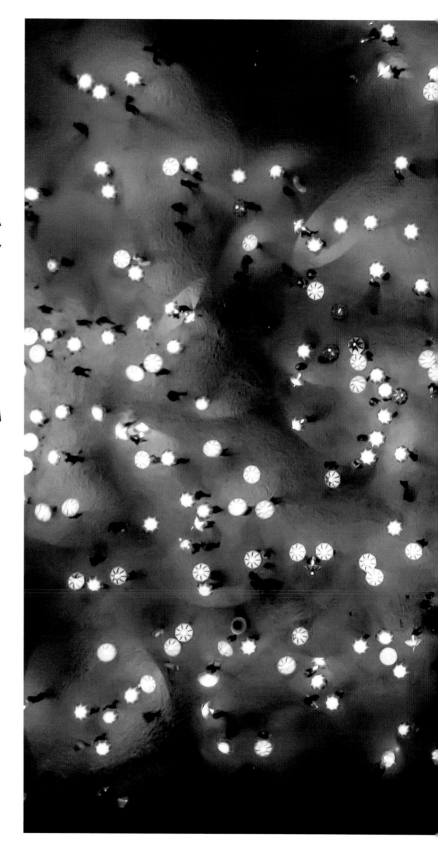

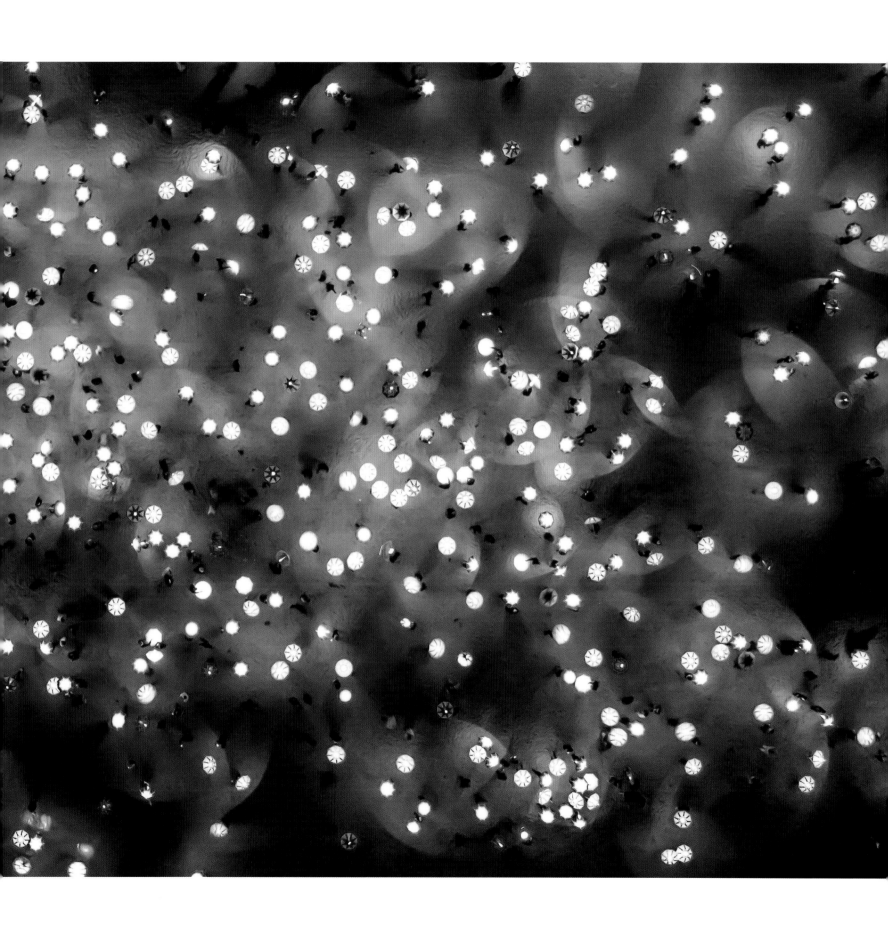

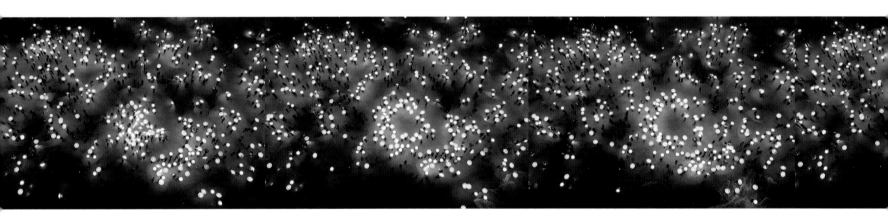

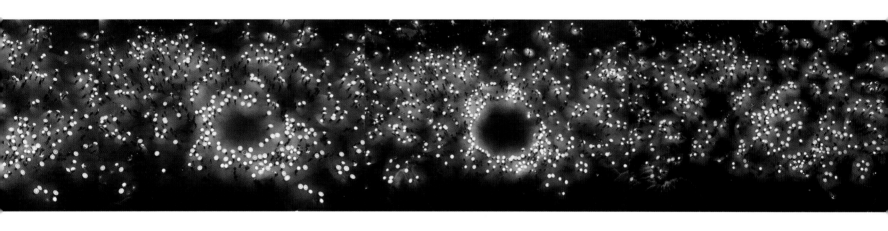

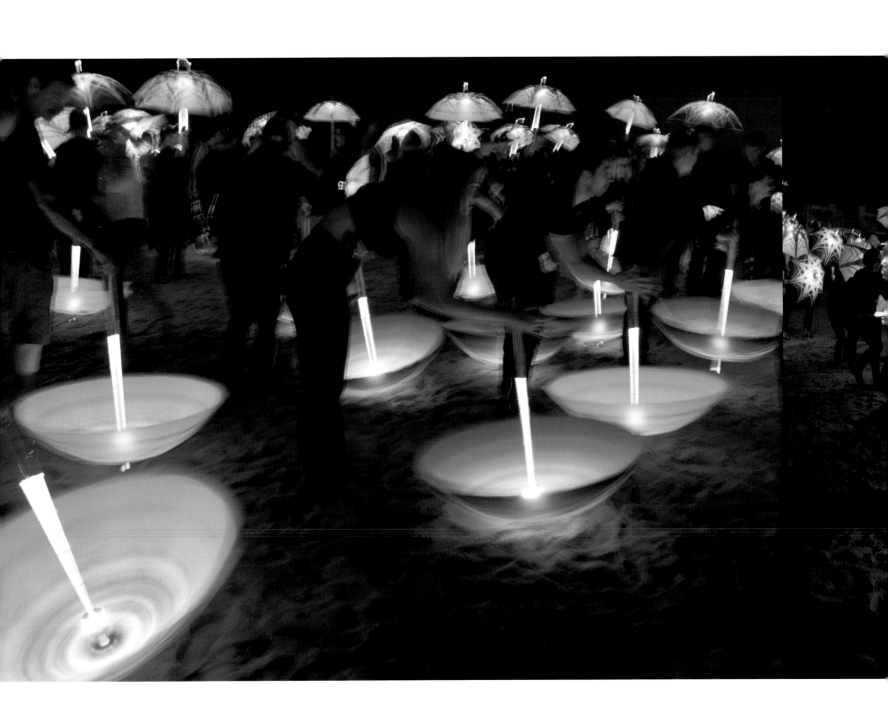

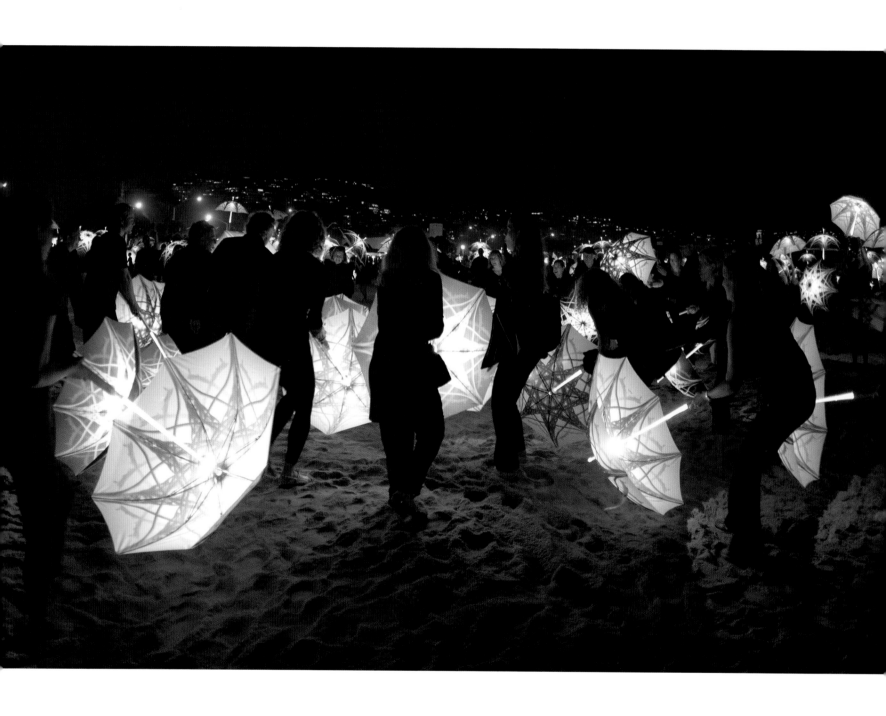

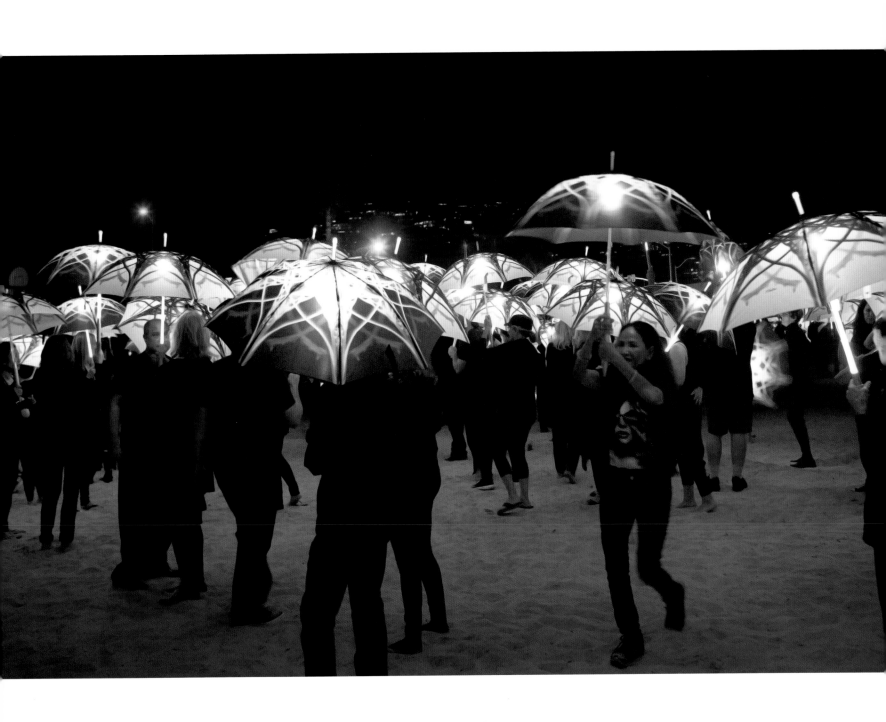

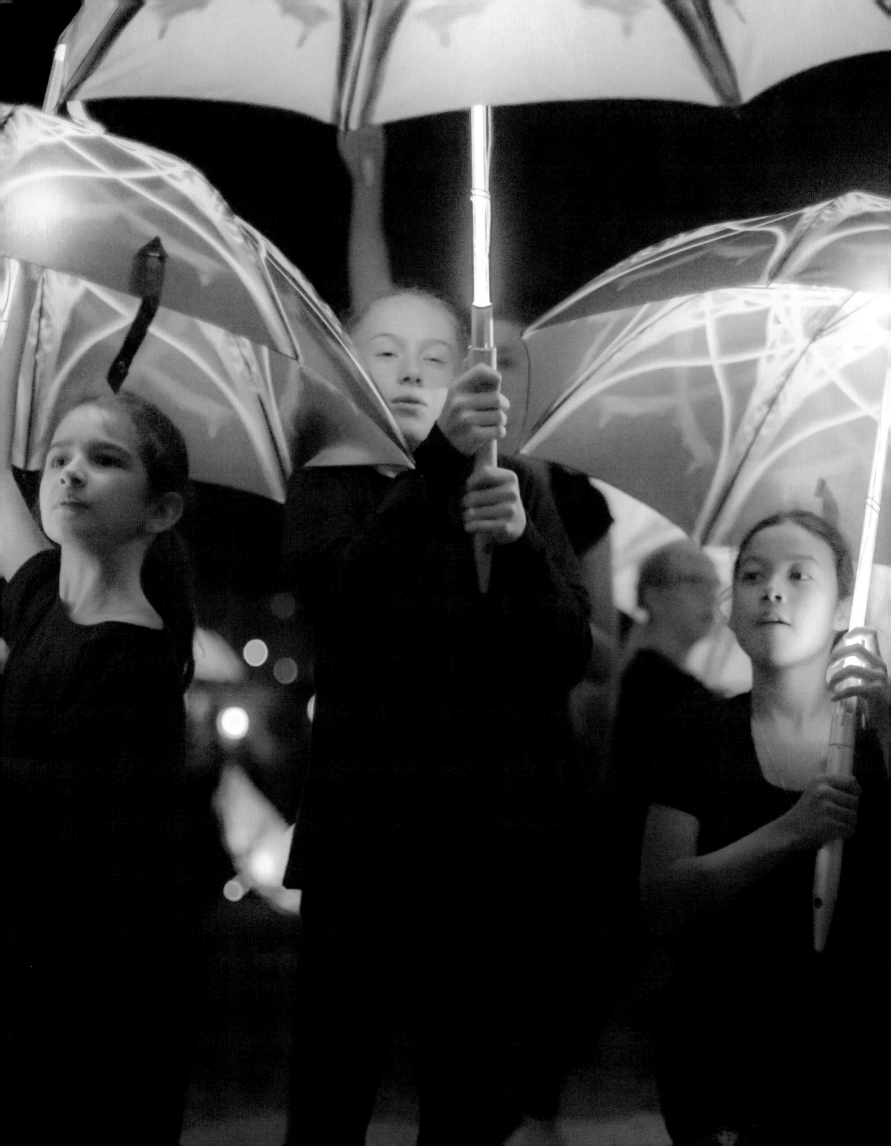

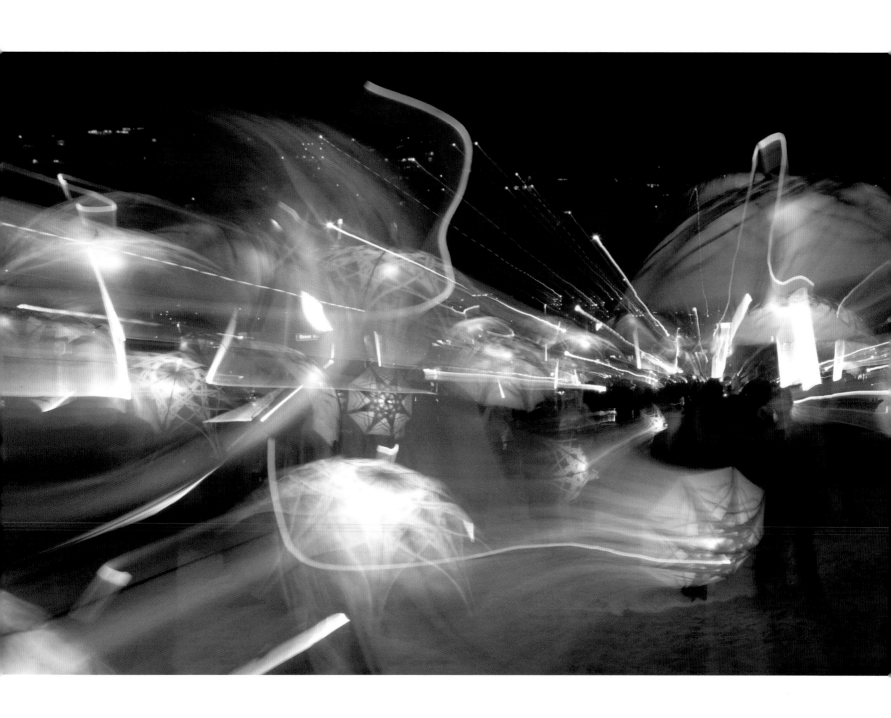

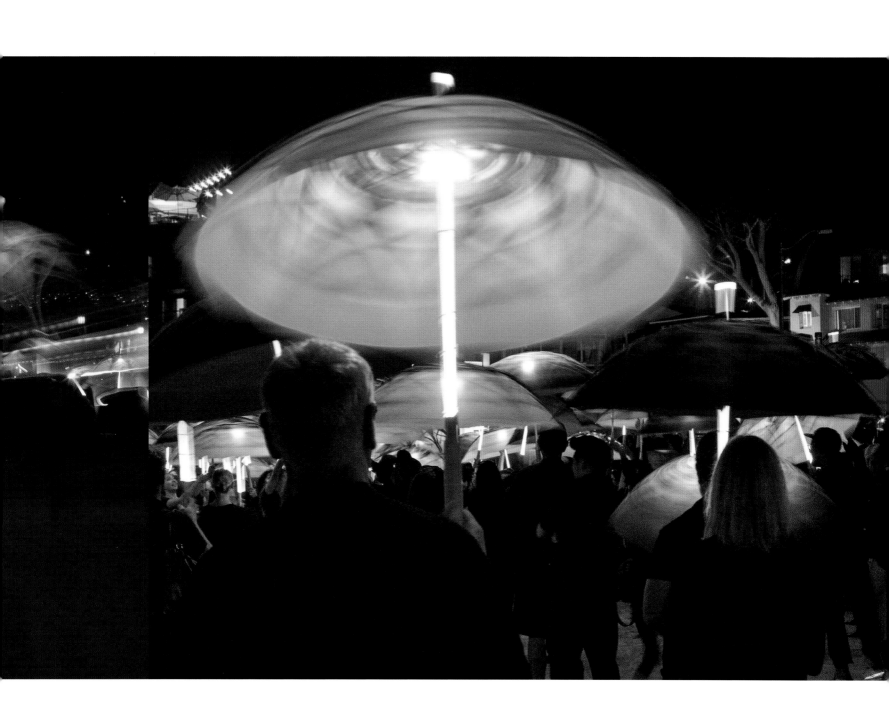

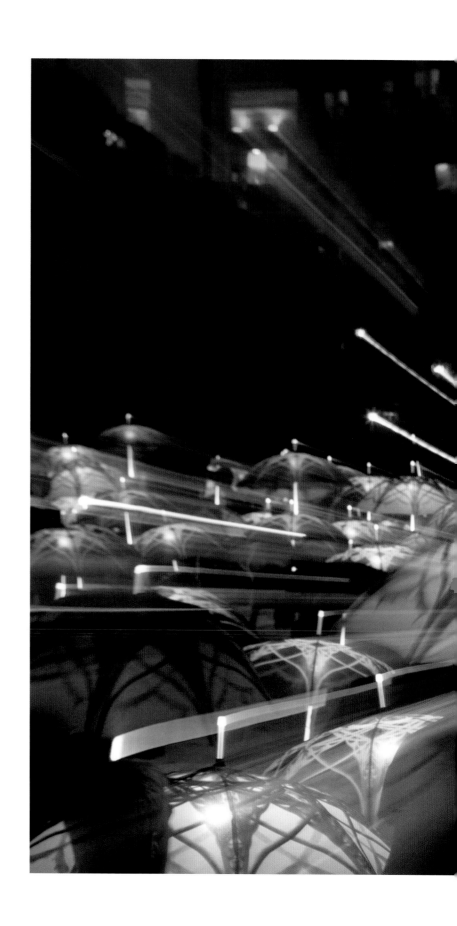

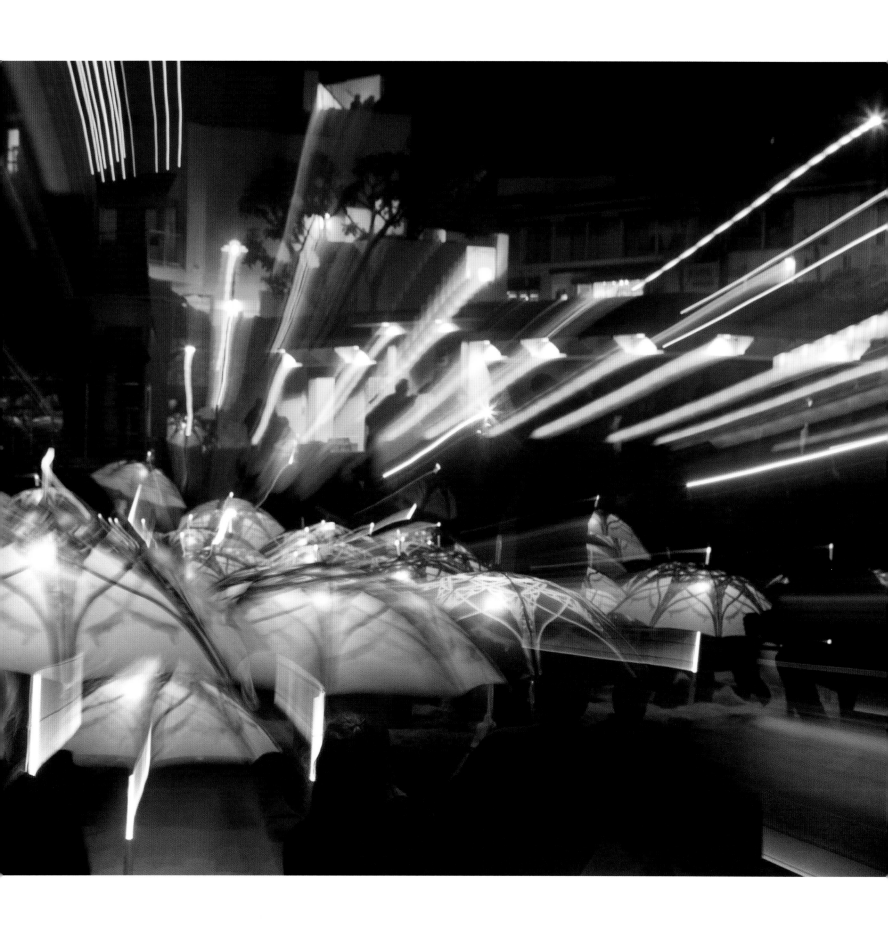

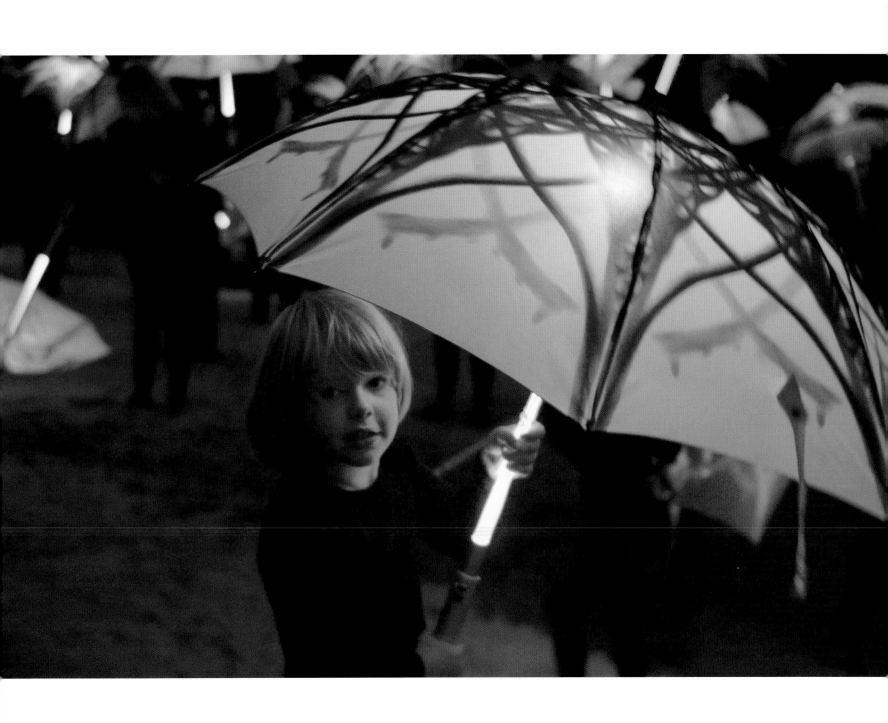

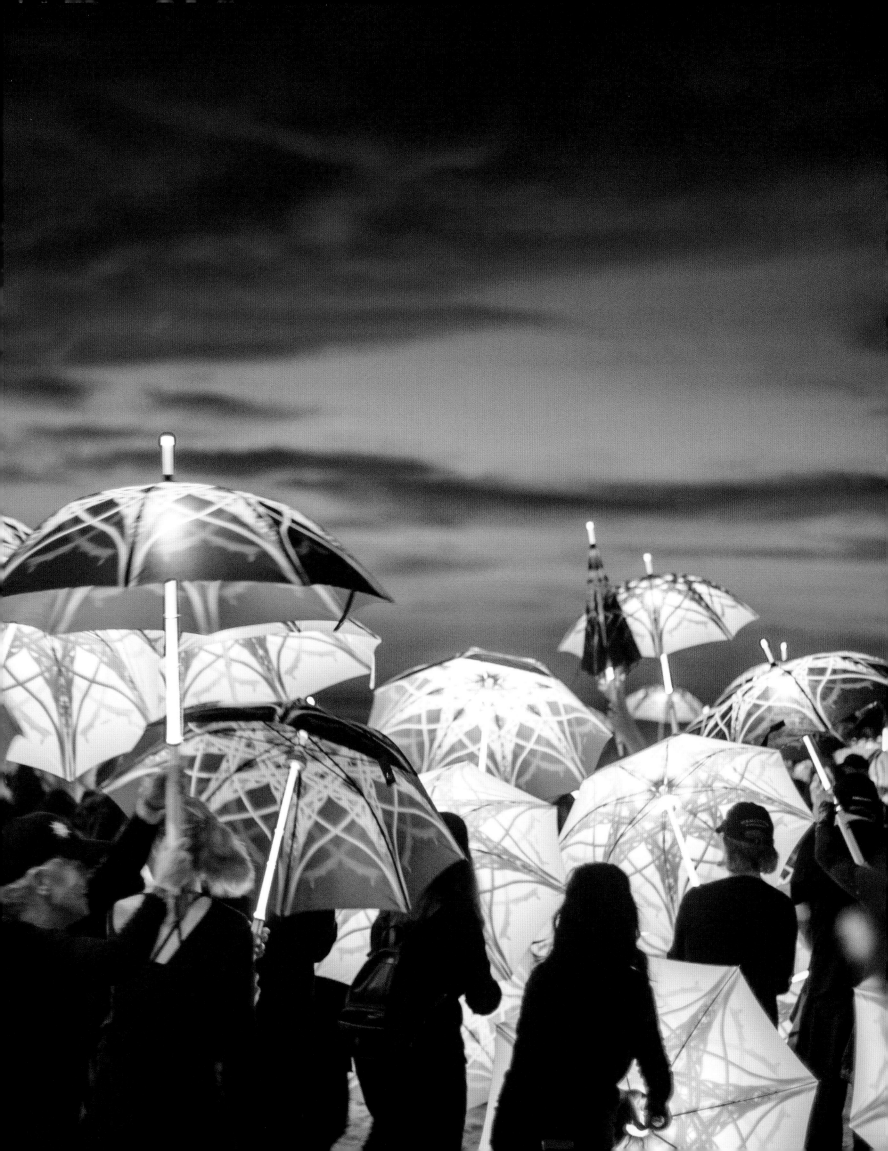

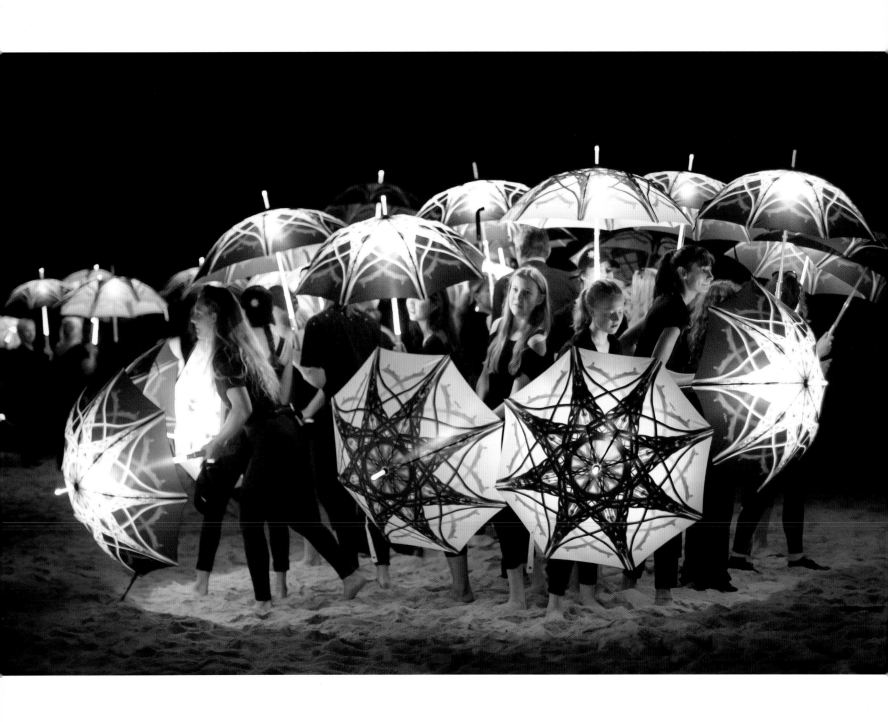

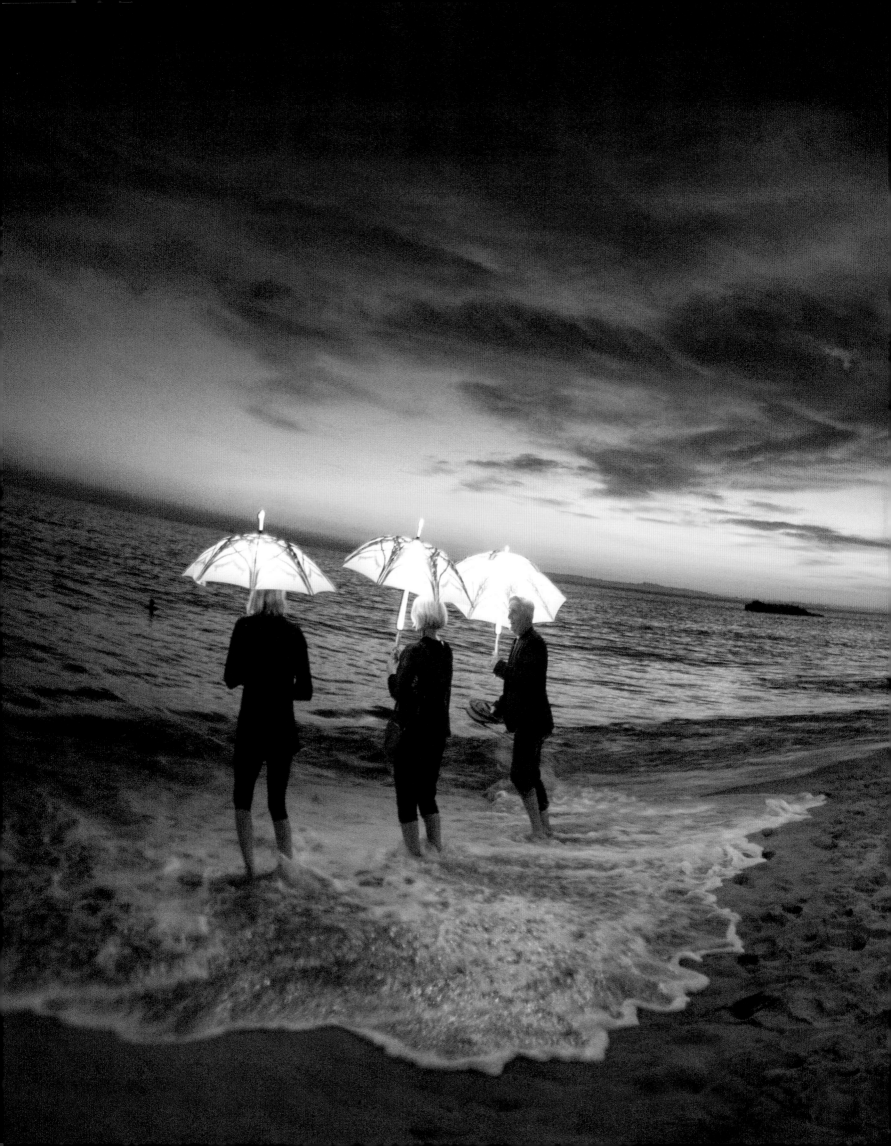

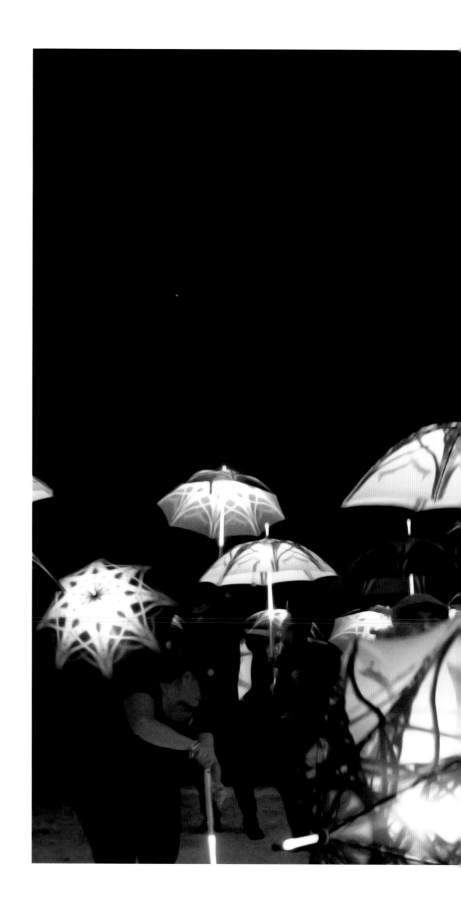

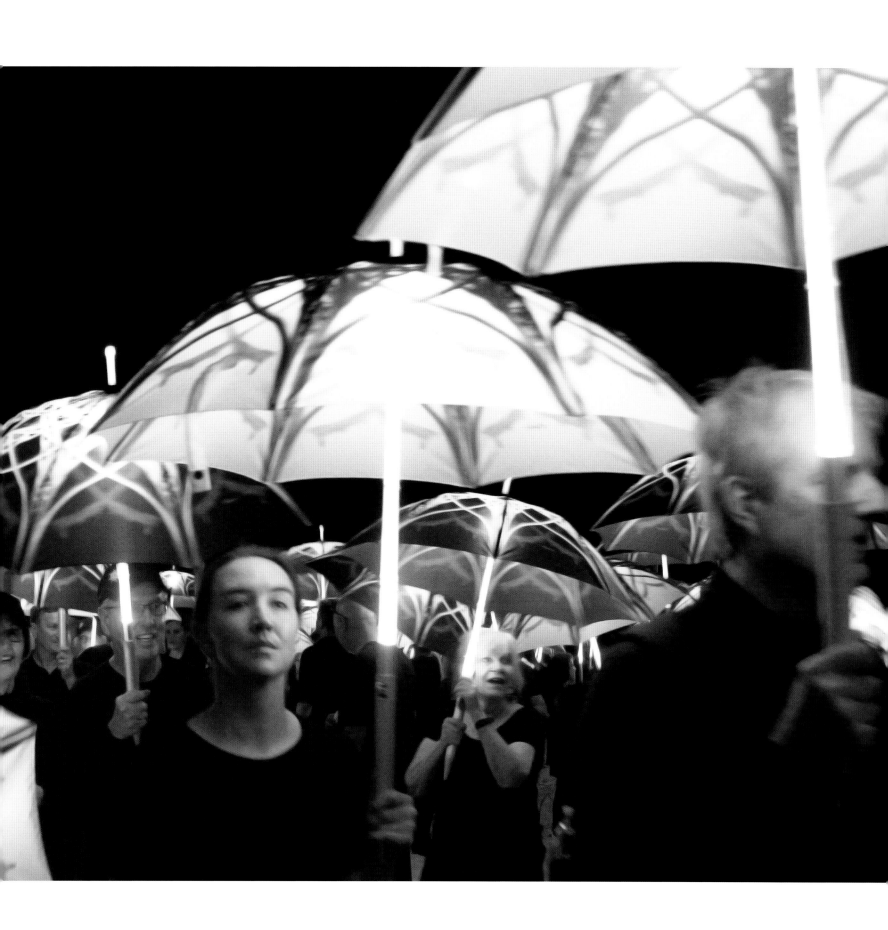

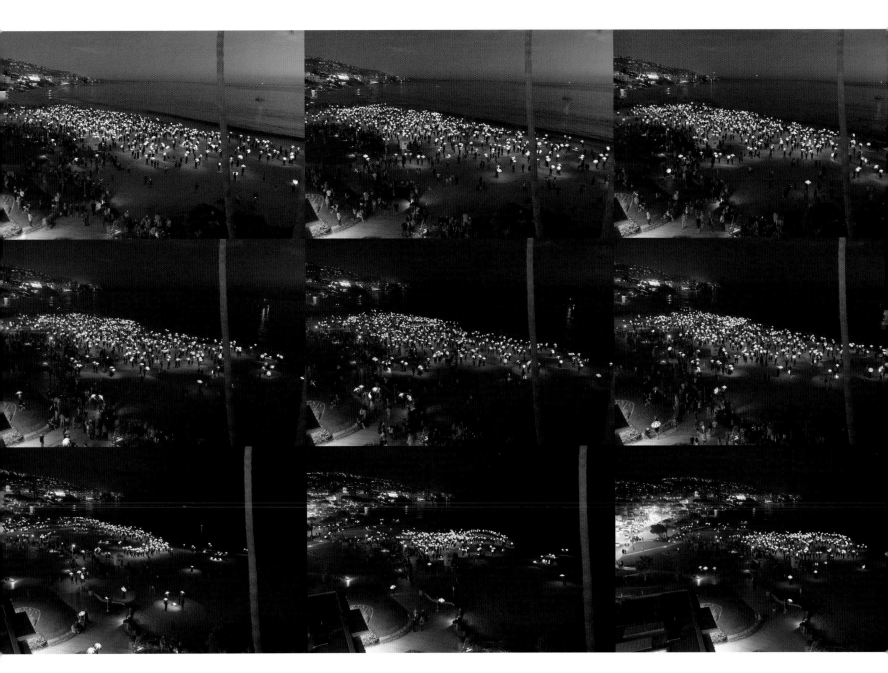

A COMMUNITY RECEDES
INTO THE CITY

1 ORGANISM BECOMES 1000

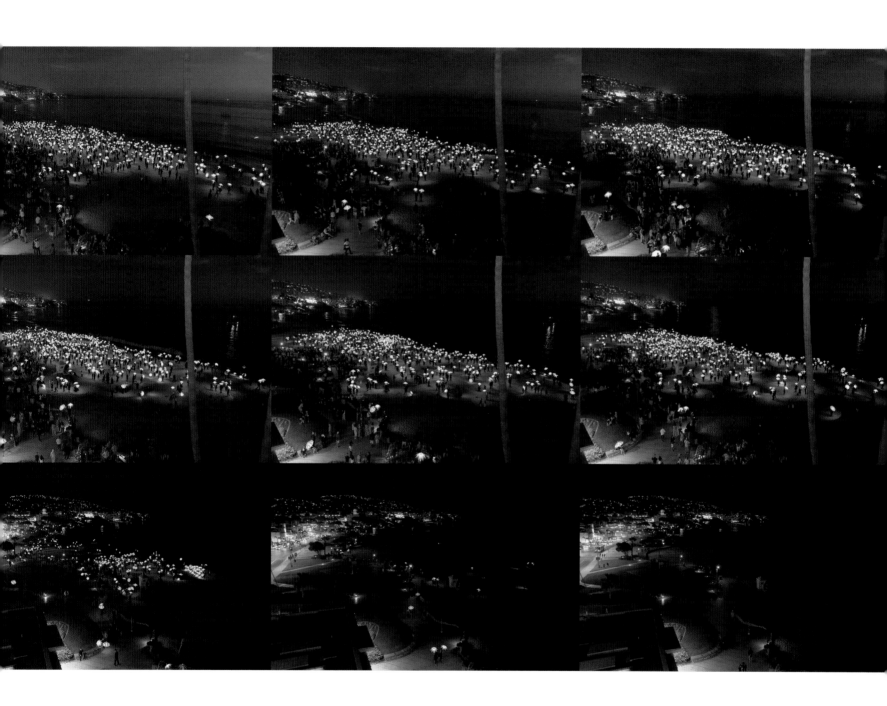

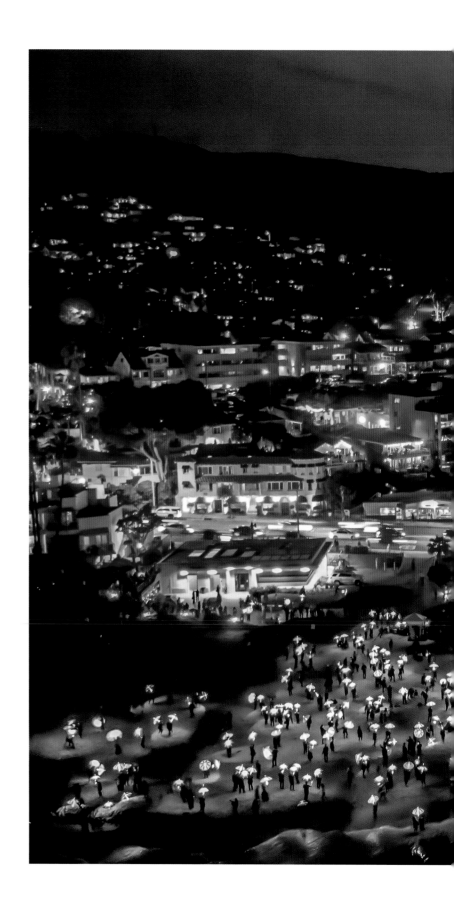

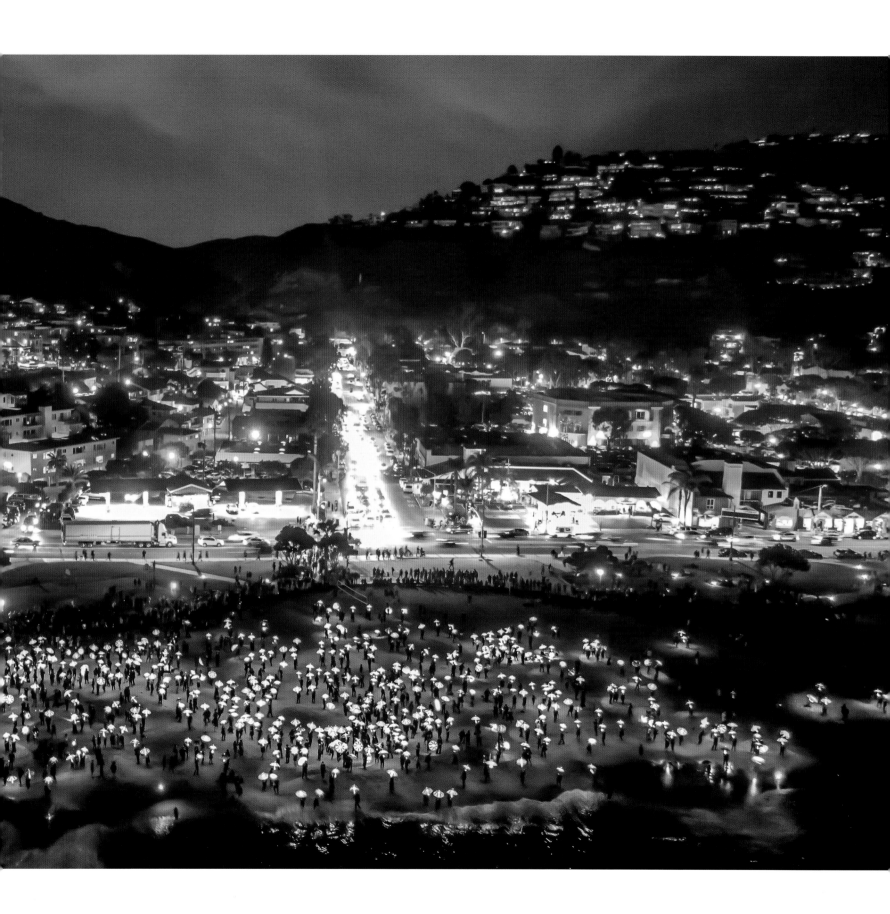

ET STUDIOS

**ET STUDIOS FORMED TO MAKE CHANGE
VIA CREATIVE ARTS.**

Formalized in 2018 as a California nonprofit, the studio is an experiment. Our goal is to launch creative projects using Orange County, California, as a collaborative laboratory. Organized organically, we are tapping into the creative explosion in our area. We are motivated to merge art, science, and nature into simple experiences inspiring fresh vision and optimism.

Thank you to all Shoreline Project participants for contributing your magic to a night of joy and for leaving our beach pristine. A production of this size takes an enormous effort. Shoreline Project could not have been created, organized, and produced without the hard work of many individuals. I am grateful for the extra hours, night and day over the past two years, from all of you who took our idea to heart. Shoreline Project expanded our lives because of you.

Thank you.

Elizabeth Turk

ARTIST'S ACKNOWLEDGMENTS

WHY Shoreline Project?

**There are times when individuals and communities work in harmony.
Shoreline Project brings people together to share an experience of joy and laughter—
a moment in time that reminds us of our connection to one another and to nature.**

Elizabeth Turk

Laguna Art Museum: *Malcolm Warner*, Executive Director
City of Laguna Beach: *Siân Poeschl* and *Sherri Aubin*
City of Laguna Beach Police Department

ET STUDIOS:

Elizabeth Turk

Laura Siapin

Erik Thienes

Lara Wilson

DANCE

The Assembly Dance: Choreographer, *Lara Wilson*

CARLON: Choreographer, *Jay Carlon*

Chapman University Dance: *Julianne O'Brien*

Orange Coast College Dance: *Shana Menaker*

Laguna High School Dance: *Estee Fratzke*

Dance Works Dance Studio: *Rebecca Bush*

Molly Flynn Movement Collective: *Molly Flynn*

MUSIC

Cellist: *Ross Gasworth*

Laguna Drum Circle: *Billy Fried*

DISTRIBUTION OF ART UMBRELLAS

Ryman Arts

Laguna College of Art and Design: *Art Students, Julian Velarde, Jonathan Burke, and Brian Heggie*

Orange Coast College: *Art Students and Leland Paxton*

Scripps College: *Art Students and Alumni*

SCAPE Gallery: *Jeannie Denholm, Kathleen Updyke Brown, and Vivian Browne*

INTERNS

Sophia Silane

Victoria Browne

Chiara Kaufman

Tegan Wright

PRODUCTION OF UMBRELLAS

Smithsonian Art and Research Fellowship

Specialz: *Dave Smith*

Logotek: *Phil Page*

RESEARCH

Sherman Gardens Library: *Paul Wormser*

Laguna Historical Society

PHOTOGRAPHY
AND VIDEO

Floating Lantern Production House: *Erik Thienes*
Rubinski Works: *Mike Thienes* and *Madison Holler*
Orange Coast College: *Dan Hopkinson* and *Ryan Espinoza*
Drone Operator: *Christopher Stobie*
Still Photography: *Eric Stoner* and *Mike Townsend*
Special thanks for image organization to *Enrique Del Rivero at OCC.*

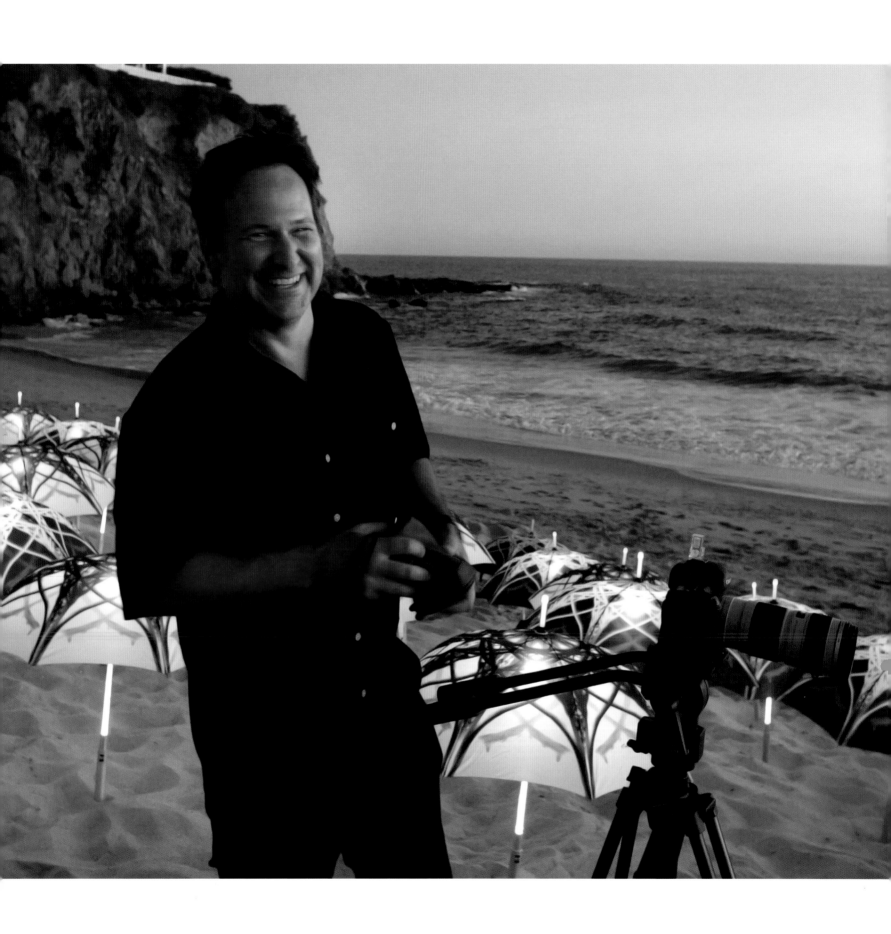

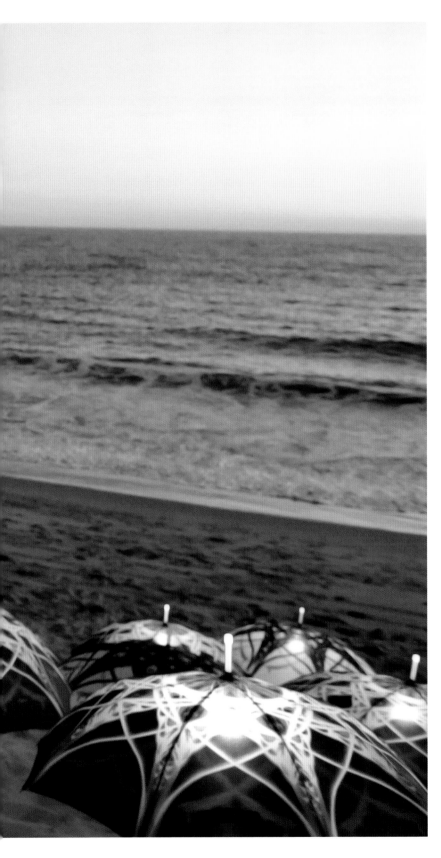

A special thanks to Erik Thienes, Floating Lantern Production House, for all his work in developing the arcs of light needed to create the gorgeous images, which have been captured by everyone.

We are grateful for all community photographers who shared magnanimously; your photography is stunning.

Thank you.

Published in conjunction with
Shoreline Project by Elizabeth Turk,
part of the Laguna Art Museum's
Art & Nature festival, November 3, 2018

PUBLISHED BY

LAGUNA ART MUSEUM
307 Cliff Drive
Laguna Beach, CA 92651
www.lagunaartmuseum.org

**CALIFORNIA STATE UNIVERSITY, FULLERTON,
GRAND CENTRAL PRESS**
800 North State College Blvd.
Fullerton, California 92831

FIRST U.S. EDITION © 2019
Laguna Art Museum
California State University, Fullerton,
Grand Central Press
ET Studios

ISBN
9780940872486

LIBRARY OF CONGRESS CONTROL NUMBER
2019943504

LAGUNA ART MUSEUM
Malcolm Warner, *Executive Director*
Kristen Anthony, *Education Associate*
Janet Blake, *Curator of Historical Art*
Tim Campbell, *Collections Manager*
Bernadette Clemens, *Director of Advancement*
Sara Gale, *Events and Development Manager*
Cody Lee, *Director of Communications*
Dawn Minegar, *Registrar*
Caitlin Reller, *Assistant Curator of Education*
Paul Salomon, *Assistant Director of Operations*
Peter Salomon, *Business Manager*
Tim Schwab, *Director of Design and Installation*
Marinta Skupin, *Curator of Education*
Joelle Warlick, *Grants and Donor Relations Officer*
Joel Woodard, *Director of Operations*
Leilani Yamanishi, *Visitor Services and Membership Manager*

**CALIFORNIA STATE UNIVERSITY, FULLERTON
CSUF DEPARTMENT OF VISUAL ARTS**
Dale Merrill, *College of the Arts Dean*
Jade Jewett, *Department of Visual Arts Chair*
Karen Crews Hendon, *Interim Director, CSUF Begovich Gallery*
Jacqueline Bunge, *Gallery Program Curator, CSUF Begovich Gallery*

Copy Editor: Sue Henger
Book Designer: James Scott and Laura Siapin
Photography and Video: Erik Thienes, Floating Lantern Production House;
Mike Thienes and Madison Holler, Rubinski Works; Dan Hopkinson and
Ryan Espinoza, Orange Coast College; Christopher Stobie, drone operator;
Eric Stoner and Mike Townsend, still photography.

Distributed by SCB Distributors
Printed by Permanent Printing Limited, China

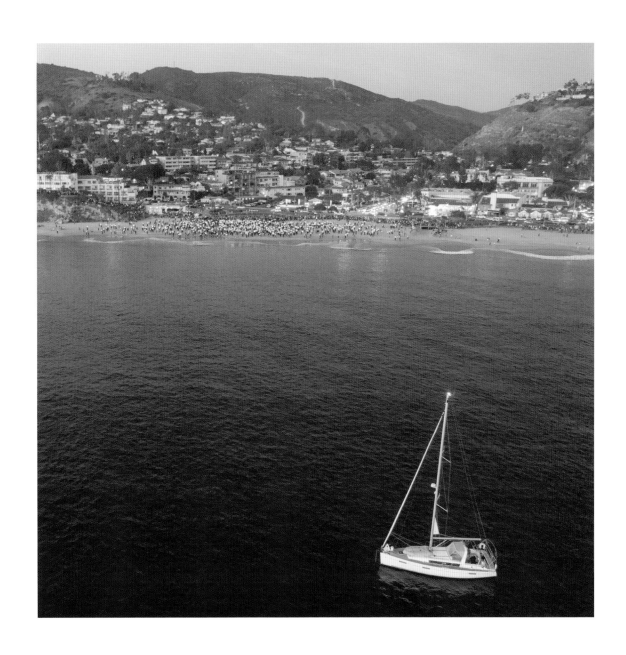